LOST JARROW

PAUL PERRY

AMBERLEY

First published 2019

Amberley Publishing
The Hill, Stroud
Gloucestershire, GL5 4EP

www.amberley-books.com

British Library Cataloguing in Publication Data.

A catalogue record for this book is available from the British Library.

ISBN 978 1 4456 9296 8 (print)
ISBN 978 1 4456 9297 5 (ebook)

Origination by Amberley Publishing.
Printed in the UK.

Introduction

As the 1900s dawned and Jarrow entered a new epoch, the town was a bustling hive of industry. The shipyards foundries and factories were all in full production and the shops almost bursting at the seams with people. In the meantime, street photographers were waiting patiently with their bulky and cumbersome cameras, captivated by social and technological change. They recorded the chaos of our busy streets, row upon row of terraced houses and the lives of the people who lived in them. Every one of these old houses had a story to tell. Their architectural history will have evolved over different eras; changing tastes and fashions will have left their mark within the decoration and fittings, revealing their secrets to many generations.

One of the more distinguished period houses in the east of the town is Jarrow Hall, built for industrialist and entrepreneur Simon Temple in 1795, which could tell a tale or two – if only its 2-foot-thick walls could speak! Another of these fine residences, Jarrow Lodge, was home to antiquarian and devoted enthusiast of ornithology John Straker, and constructed on the southern edge of the 'slake' where he housed a museum containing at least one of each species of migratory and native birds. Perhaps the most imposing is Simonside Hall, which was the home of magistrate Henry Major and commanded splendid views of the River Tyne and neighbouring countryside.

In sheer contrast to this, redevelopment of the riverside at Jarrow and the threat of demolition drew interest from landscape photographers to the area who were eager to record and document these fine halls of residence, the old riverside cottages and anything of historical merit before they disappeared forever. They were also adept at capturing business names and landmarks that offered important clues for placing the images they recorded in time and place. By the 1920s, and as cameras became cheaper and easier to use, professional and amateur photographers became the prime archivists of such material for inquisitive onlookers. The devoted cameramen often diversified by recording the rolling waves of the country's rocky coastline, the ragged peaks rising above steep and enchanting valleys, deep and clear freshwater rivers and cascading waterfalls, all of which offered spectacular photographic opportunities.

The forthcoming pages will reveal, in fascinating detail, just how much the town has changed and even what has been lost in a relatively short space of time. Gratitude must surely go to such early pioneering photographers and historians who, between them, did so much to record and preserve the changing face of the town over the past 150 or so years, creating an important record of thousands of photographs and detailed descriptions of them portraying the transformation of the town. Many of these images were taken as some of the town's older buildings were demolished, making way for new

roads and more modern buildings. This volume is another in a recent series of local history books published by Amberley. Rather than looking solely at the changing face of towns and villages, it looks, as the title suggests, especially at what has disappeared.

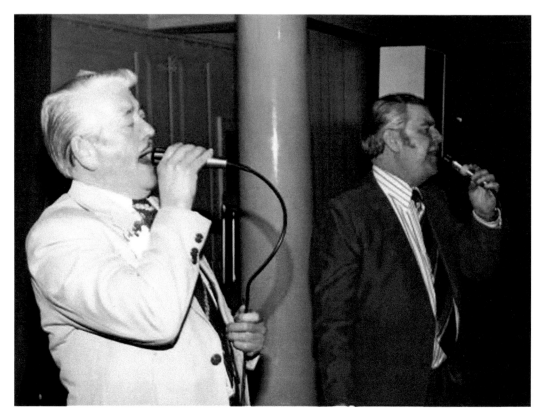

It was a chance meeting at a Middlesbrough shipyard that brought two 'Jarra lads', Thomas Mullen and Thomas Rowan, together as singing duo the Two Toms. Their first public appearance as a duo was at The Eckland, a public house close to the shipyard in which they were employed. Here they performed, their first attempt at harmonising together, their rendition of two classic melodies: 'If I Loved You' and 'Some Enchanted Evening'. As usual, being a Sunday lunchtime, the Middleburgh venue was packed to capacity and the smiling pair returned to their seats to rapturous applause. Eventually the men were transferred closer to home, to a sister shipyard at North Shields. As they both lived close to one another in Jarrow, their first gig in their home town was at The Alkali Hotel in the east end of the town, and it didn't take long for word of the popular crooners to spread throughout Tyneside. Their popularity spread to the four corners of the region and they sang at charity events and talent competitions, entertaining thousands for many years at venues north and south of the River Tyne. With mellow tones and velvet voices, the casual singing career of the Two Toms made an unforgettable contribution to the rich tapestry and history of Jarrow.

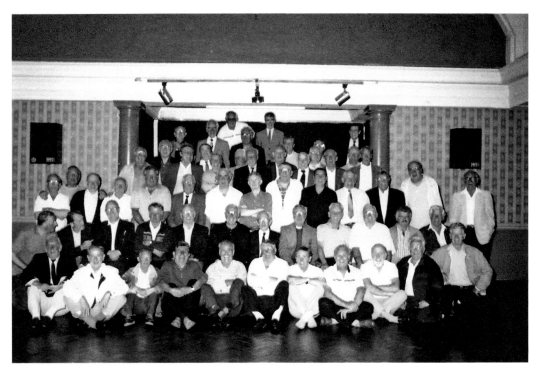

Former pupils of St Bede's School, Harold Street, pose for this group photograph at a reunion at the parish centre in Albert Road, just prior to the centre's closure in November 1995.

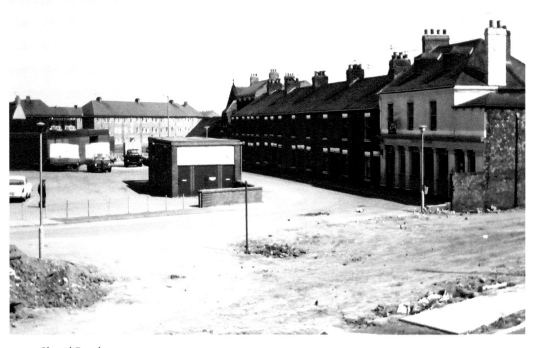

Chapel Road, 1970.

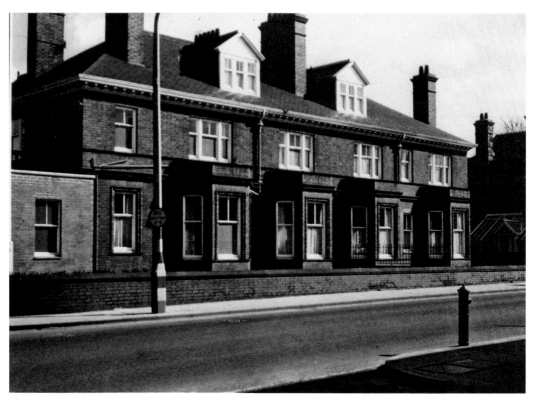

Danesfield Maternity Hospital, Bede Burn Road, 1975.

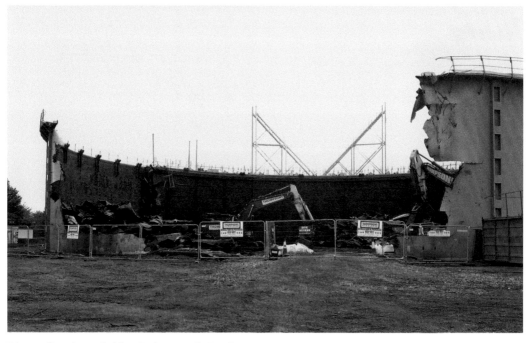

Dismantling the gasholder, Curlew Road, October 2017.

Born in 1906 at South Shields, Katie McMullen found fame in 1950 as novelist Catherine Cookson. She eventually penned no less than 100 novels that were translated into twenty or so languages, the majority of which were based upon her deprived childhood in north-east England. Katie was the illegitimate child of an alcoholic mother who grew up believing her mother (also called Katie) was her sister. Raised by her grandparents, Rose and John McMullen, at William Black Street, Jarrow, the young Katie left school aged fourteen and worked briefly as a domestic servant and later toiled fifteen hours a day in a laundry at a South Shields workhouse. By 1929 she had relocated to Hastings on the south coast and worked in another workhouse laundry. Eventually she earned enough money to purchase a large Victorian dwelling, taking in lodgers to supplement her income. In 1940, at the age of thirty-four, she married Tom Cookson. After a lengthy spell of ill health, she took to writing to battle against severe depression. Her first romantic novel, published in 1950, was *Kate Hannigan*, which became a stepping stone for many more great works, many of which were adapted for stage, screen and television. The first memorable television adaption of one of her novels was *The Fifteen Streets* in 1990, followed by *The Black Velvet Gown* in 1991. The honour of Officer of the Order of the British Empire was bestowed upon her in 1985, and she was elevated to Dame Commander of the British Empire in 1990. After a marked decline in the novelist's health problems, Tom and Catherine returned to the north-east, and after a spell in Newcastle they relocated to Corbridge and Langley in Northumberland. After a further deterioration in her health, the couple were forced to relocate back to Newcastle in 1989, which was closer to vital medical facilities. Catherine bequeathed in excess of £1 million of her vast wealth to local health organisations, including Newcastle University, to assist in the relief of suffering, prior to her passing in 1998. Her husband Tom passed away less than three weeks later.

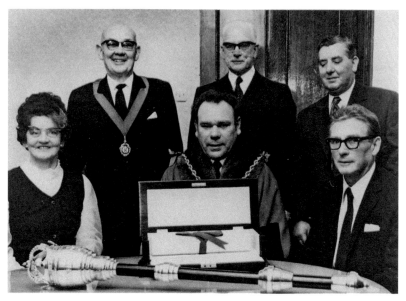

Staffordshire-born Labour Party politician Ernest Fernyhough commenced his political career aged just twenty-six as member of the National Union of Shop, Distributive & Allied Workers (USDAW) from 1936 to 1947. From this time the popular politician was elected as Member of Parliament for Jarrow after the sudden death of the town's former MP, Ellen Wilkinson. Fernyhough held the seat and position of Member of Parliament until his retirement in 1979. He was succeeded by Councillor Don Dixon (later Baron Dixon) who held the position until his retirement in 1997. The position from this time to the present day is held by Stephen Hepburn. Fernyhough was Parliamentary Private Secretary to Prime Minister Harold Wilson from 1964 to 1967, then Junior Minister for Employment and Productivity until 1969, followed by a promotion by the prime minister to the office of the Council of Europe for a period of three years until 1973. After a long and successful career as a politician and parliamentarian, Ernest Fernyhough passed away at Cheshire in 1993, aged eighty-four years. Pictured: Mayor Don Dixon, town councillors and Jarrow MP Ernest Fernyhough seated right in this image from 1971.

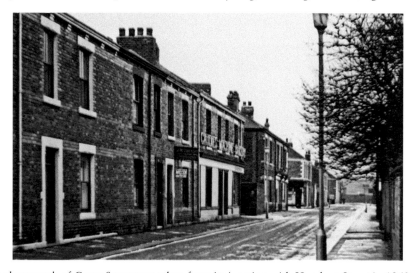

This photograph of Grant Street was taken from its junction with Humbert Street in 1960.

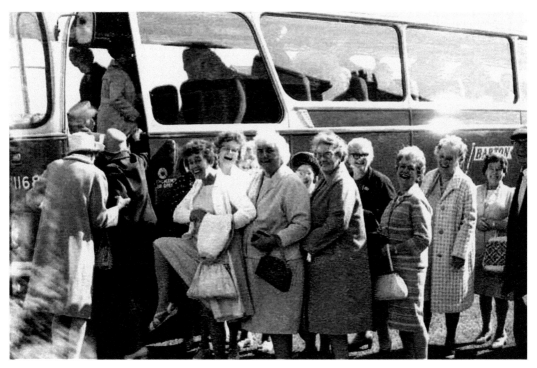

Calf Close over-sixties club preparing for their annual outing to the seaside, July 1971.

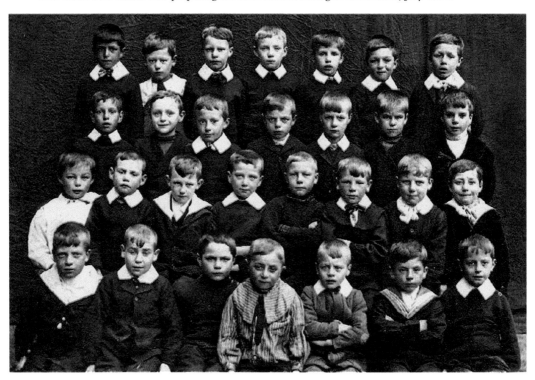

St Peter's School class photograph, 1910.

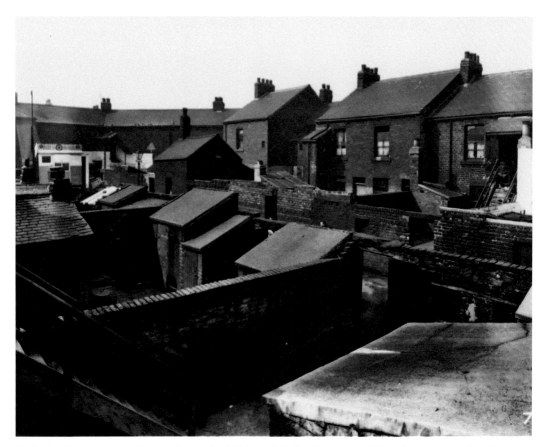

Typical of the housing in Jarrow during the 1920s and 1930s. On many 1940s winter nights, after the children were bathed in front of a roaring fire, families entertained themselves by making a 'clippie mat'. The enormous frame upon which they worked took up much of the living space of the single room the huge families lived, ate and slept in. These crude makeshift mats, which seemed to take forever to make, were a cheap alternative during the lean times. They were made from disused clothing and blankets cut into manageable-sized pieces and fixed to a canvas backing with a hook similar to that used in crocheting.

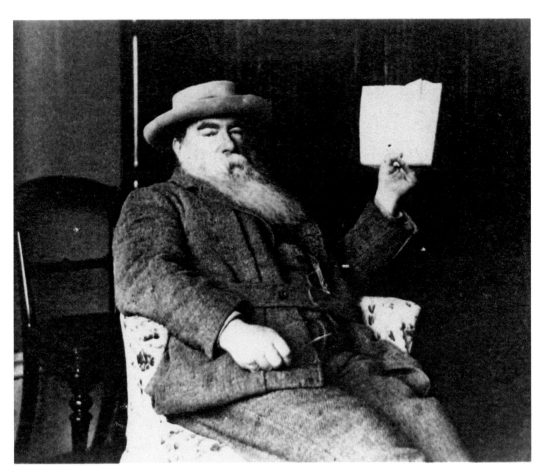

The spa village of Croft in the ancient parish of Richmondshire, North Yorkshire, is mentioned in the Domesday Book as 'Crofst'. It eventually came into the hands of the Clervaux family around 1590 when, soon after, the direct male line ceased to exist. The Clervaux inheritance continued via marriage into the Chaytor family, who, at that particular time, were a landowning family of substance from Jarrow. A descendant of the family, Alfred Henry Chaytor, son of John Clervaux Chaytor and Emma Fearon, graduated from Clare College Cambridge and inherited Jarrow Hall in 1910 after the passing of his adopted uncle Drewett Ormonde Drewett (pictured). The Clervaux family were extremely wealthy and influential landowners who resided in Clervaux Castle in North Yorkshire. They owned a considerable amount of land, including the villages of Hurworth and Croft. Thomas Drewett Brown married Isabella Chaytor and inherited a sizeable estate at Jarrow, which included Jarrow Hall and the surrounding area. Similar to many citizens of Jarrow who had thoroughfares named in their honour, Hurworth Place, Croft Terrace and Clervaux Terrace were duly named in memory of the Clervaux family of North Yorkshire.

Above and below: Second World War damage caused many unwelcome alterations to parts of Jarrow. Dunn Street School, pictured here in 1955, suffered considerable and irreparable damage as it was all but demolished during an enemy bombing raid in 1941. Local residents rallied unsuccessfully in a desperate attempt to save the school, which was deemed beyond repair. The main building was subsequently demolished, with the exception of the schoolhouse and a prefabricated building. Eventually these buildings were also demolished during the 1960s. The lower image shows a class of girls from the school in 1912.

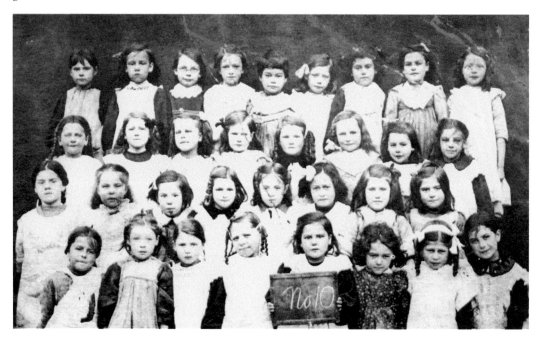

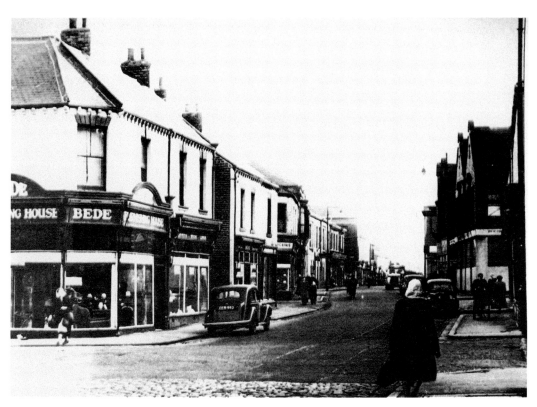

Ormonde Street, 1952.

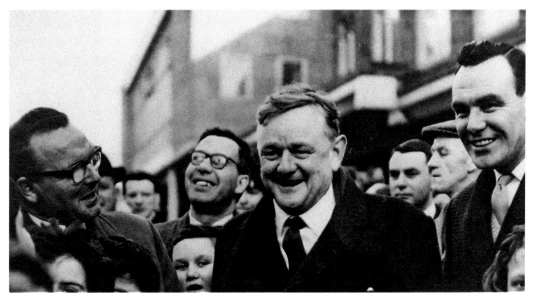

Minister of Employment Lord Hailsham, formerly Quentin Hogg MP, travelled north to Jarrow in an attempt to resolve the employment issues the town was experiencing in 1963. This unemployment black spot was reminiscent of the dark days of the 1930s, and again was one of the worst in the country at that particular time. Pictured here is Lord Hailsham talking to Jarrow residents at the Arndale Centre.

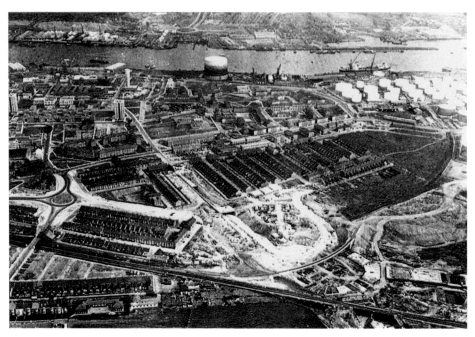

Aerial photograph showing the progress of the construction of the Tyne Road Tunnel in 1960.

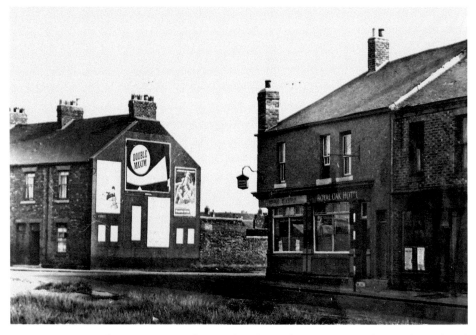

Kitty Monroe's, or the 'Long Bar' as the Royal Oak Hotel in Grange Road was often referred to for decades, was a meeting place for many of the town's adopted Irish immigrants who came to Jarrow seeking work, settling here in the early part of the twentieth century. Their welcome presence and labour contributed so much towards the provision of housing for thousands of shipyard workers in what was a boom town. This influx of Irish workers was to regard Jarrow, or 'Little Ireland' as it became known, as their home.

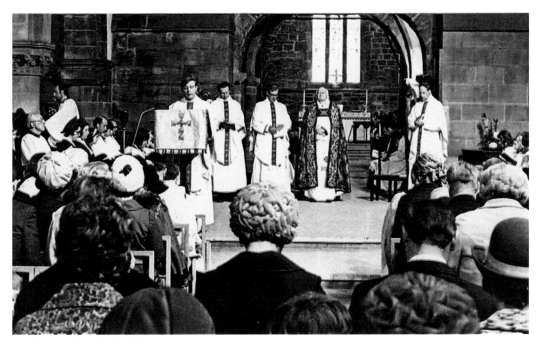

Above and below: Archbishop of Canterbury Dr Michael Ramsay, latterly Lord Ramsay of Canterbury, visited the town in 1973 to conduct a service at St Paul's Church as part of the Venerable Bede celebrations. Ramsay's wife, Joan Hamilton, who he married in 1942, was familiar with the town as for a number of years she was private and personnel secretary to Dr Leslie Owen, Bishop of Jarrow. Pictured here are the archbishop and choir at St Paul's Church in 1973.

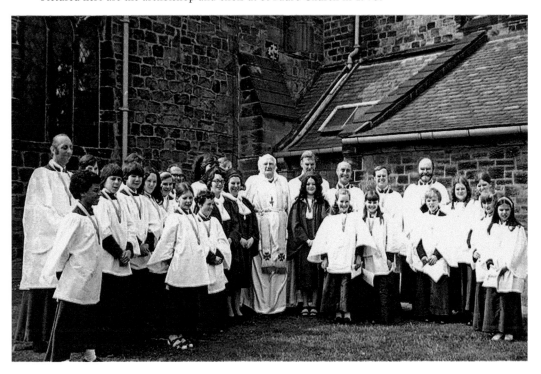

After thirteen years of a Tory government, the Labour Party returned to power in 1964. The election was far from a landslide victory; it was won by a majority of just four seats. Three years after Yorkshireman Harold Wilson was elected into No. 10, he came to Jarrow during a countrywide tour. This was at a time of uncertainty and unemployment. During his visit, he unveiled a plaque at the Civic Hall dedicated to the town's most colourful and memorable Member of Parliament, Ellen Wilkinson. Pictured here is Harold Wilson at Jarrow in 1967.

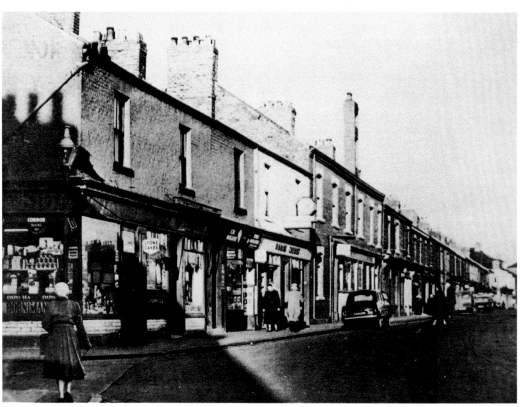

Monkton Road, 1953.

Above and below: Because of the war years and the bomb damage Jarrow suffered from as a result, education became an issue. Dunn Street C of E School was devastated after a direct hit during the Second World War. As the majority of young teachers had been called up, school governors were forced to bring teachers out of retirement. This untimely setback meant its children were educated on a part-time basis in selected classrooms at Harold Street and the grammar school in Field Terrace and allocated places accordingly, alternating between mornings and afternoons. More suitable areas of the schools were used as emergency first-aid stations. The region's two major hospitals, the Ingham Infirmary and General Hospital, both in South Shields, had to cope with many major casualties from similar air raids, which left only Palmers and Primrose Hill Hospitals in Jarrow to deal with any emergencies. Pictured are St Bede's School, Harold Street, and Jarrow Grammar School.

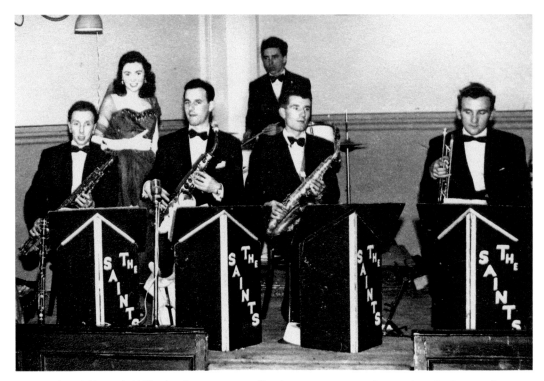

During the 1940s and 1950s dancing was generally always a very popular pastime. In Jarrow the favourite venues for these very well-attended weekend gatherings were the Max in Ellison Street and the Store Hall in North Street. Dance bands were in great demand in all parts of the north-east region. For Jarrow, the Saints Dance Band (pictured) filled this gap perfectly for several years. As the 1950s progressed, the magic and attraction of the dance band era fell from popularity as the latest craze from America – rock 'n' roll – swept the nation and discos made their debut for the very first time. Pictured here is the Saints Dance Band from 1958.

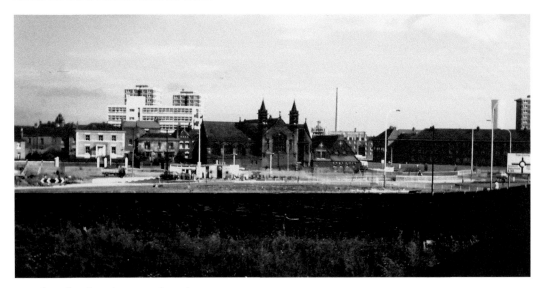

St Bede's Church and town reclamation.

Jarrow Hall and Drewett Playing Fields, 1964.

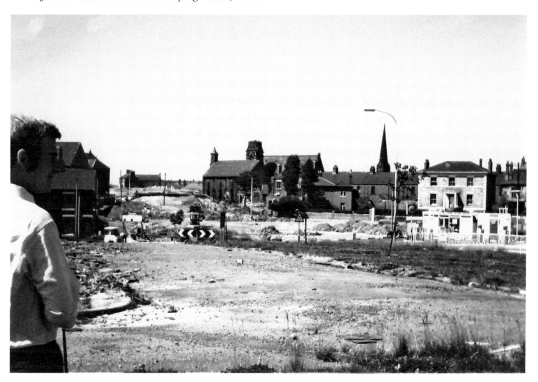

St John's Terrace and town reclamation.

Above and below: Jarrow has always had an abundance of amateur sporting heroes, and they were often headhunted to play for one or another of the many football teams active in the town. Many of these potential stars progressed to semi-professional and professional status. Those of us with less interest in sport were more suited to what church-based youth clubs had to offer. A variety of pastimes and activities were always on hand. Another attraction of these centres for teenage boys was the golden opportunity and prospect of meeting girls. The younger generation were encouraged to participate in other activities, such as the Sea Cadets, the Air Training Corps and the Territorial Army. Pictured is Jarrow ATC 1027 Squadron at RAF Wyton Cambridgeshire in 1958 and at RAF Watton Norfolk in 1959.

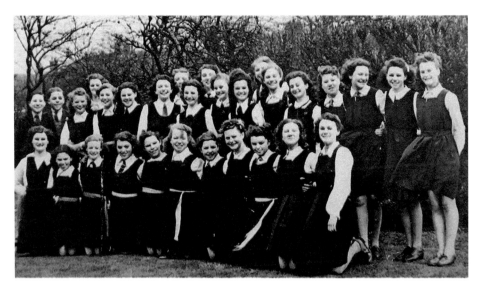

Belsfield Girls' Central School, 1947. Everything in school life had been in place since the opening years of the twentieth century. Admittedly the cane was used less discriminately than previous years and there was greater freedom to let boys and girls mix in team games, but beyond these parameters there was little change. Teachers taught huge numbers of children in classrooms where pupils sat at row upon row of desks facing the front. The controversial eleven-plus examination was dreaded by most children old enough to take the exam, which was instituted by the 1944 Education Act. The individuals fortunate enough to gain a pass mark continued their education at a very smart grammar school or similar establishment, with the remainder moving on to secondary modern education. Towards the end of the 1950s, the authorities were leaning towards comprehensive education.

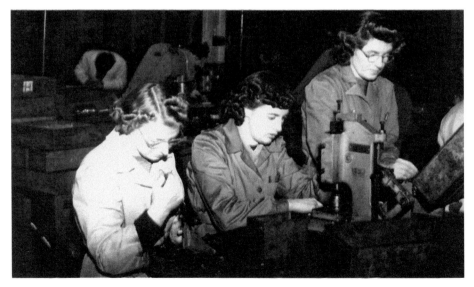

Assembly shopworkers from 1950. As time went on it became increasingly clear that some of our older and more established industries, such as coalmining and shipbuilding, were now very much in decline, while others were showing a marked improvement in productivity. The manufacture of electrical components and raw chemicals for industrial purposes created much employment, especially for the labouring classes.

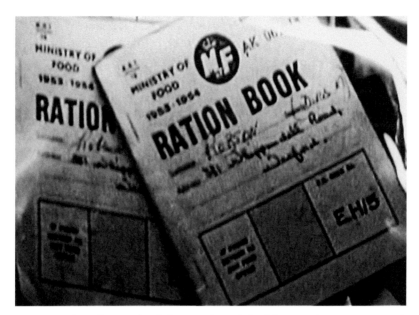

Wartime ration books. What our forefathers ate depended solely upon their income. For the very poor the staple diet was made up from bread and potatoes, occasionally supplemented with a small amount of fatty meat bolstered with a suet crust. As the 1940s dawned and food became less scarce, corned beef and hotpots were beginning to make an appearance as wartime rationing provided everyone with equal measures of what was available.

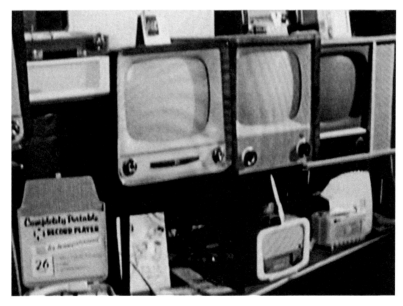

We cannot be blind to the changes that were happening all around us. After the war life in Jarrow was to return to some kind of normality with the birth of the television age. Retailers up and down the country were cashing in on the unprecedented interest as televisions were being installed in homes, just in time for the revolutionary live broadcast of the coronation of Queen Elizabeth II. The accompanying image of these 1960s two-channel televisions seem light years away from today's technology.

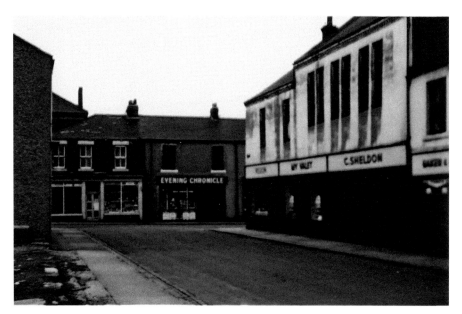

Rea's Coffee Bar & Ice Cream Parlour, Walter Street, 1955. Around 1960 coffee bars and ice-cream parlours became popular haunts for teenagers seeking company and excitement on a rain-soaked Sunday afternoon. We listened to the latest sounds coming from an enormous American-style jukebox and the whirring, gurgling and hissing melodies coming from a fierce-looking Italian manufactured Gaggia coffee machine.

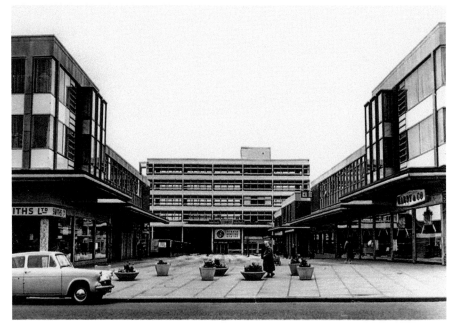

Another pastime that arrived on the scene and proved to be hugely popular with the young and old was tenpin bowling. Jarrow was chosen as the first town in north-east England to boast a purpose-built tenpin centre in 1962. Avid bowlers came from far and wide as leagues were formed for all ages in which to participate. Pictured is the bowling alley entrance in Viking Precinct, 1963.

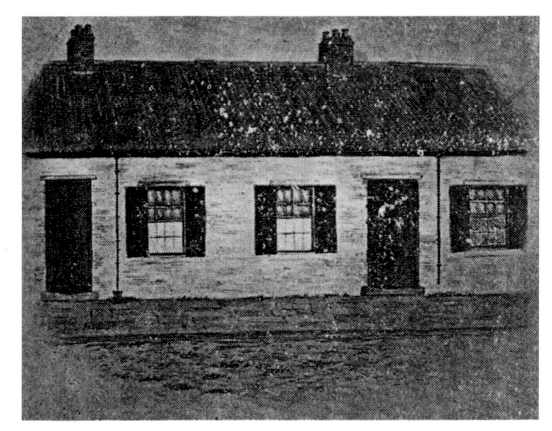

Large families lived in tiny cottages clustered together on Weavers Row – what we know today as Ferry Street. Pressure arose for more general and substantial housing around 1870, and it was agreed that some of the extensive land in the east of the town formerly used for farming should now be used for this purpose. Soon houses were beginning to spring up at East Jarrow and other locations closer to the town centre. Many of the old miners' cottages were being demolished and replaced with terraced accommodation. Pictured are white-walled miners' cottages typical of some of the accommodation in Jarrow around the beginning of the nineteenth century.

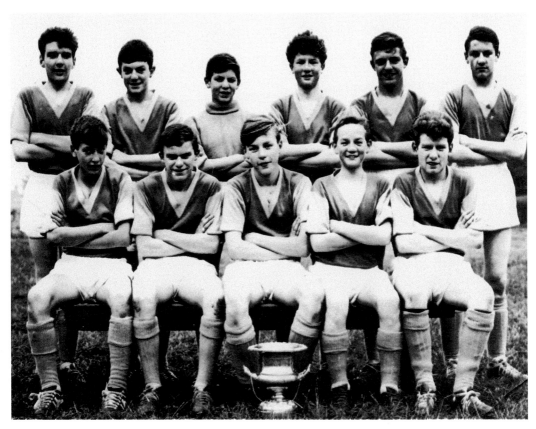

The team of the 1962/3 season comprised the crème de la crème of the Jarrow Hebburn & Felling boys' amateur football team, who beat Chester le Street two goals to one in the semi-final of the coveted Hartlepool Hospital Cup competition. The opposing team featured two future Sunderland players: defender Colin Todd and midfielder Colin Suggitt. They failed to beat the Tyneside eleven, who progressed to the final, beating the Stockton boys in front of a capacity crowd at Leslies sportsground, Hebburn. Pictured here are the line-up with the trophy. Back row, left to right: John Trainor, Robin Newbold, Rigby Jones, Anthony Hanson, Robert Quinn and David Brown. Front row, left to right: John Doughty, Bob Sibbald, Ernie Thirlwell, Ray Brown and Alec Faye.

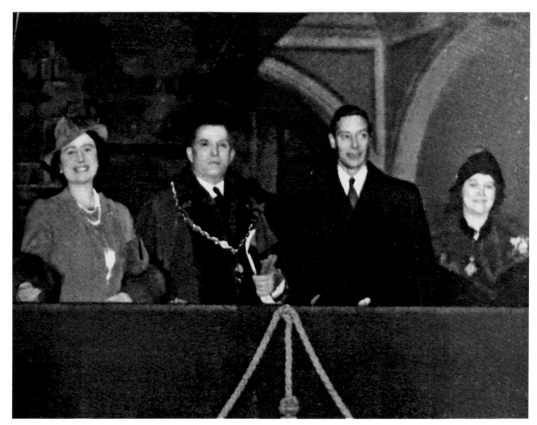

An Act of Parliament from 1885 gave municipal boroughs in England and Wales the power to award the title of honorary freeman to eminent members of the community in recognition of their services. The freemen of the borough enjoyed special privileges according to local regulations, along with the eligibility to vote in parliamentary elections. One of the most memorable freemen of the borough of Jarrow was Alderman Alfred Allen Rennie JP. He was elected to the town council in 1925 and served Jarrow as chairman on several committees, holding the position of chairman of the Labour Party Council Group for in excess of twenty years. Alderman Rennie was elected mayor of Jarrow in 1939. In this image Mayor Alderman Rennie welcomes King George VI and Queen Elizabeth to Jarrow in 1939.

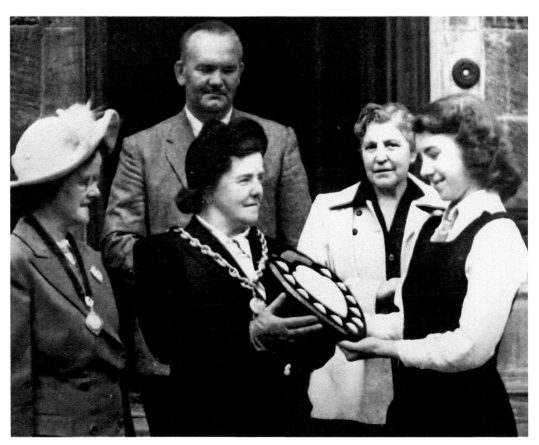

As 1950 dawned the country was preparing for the forthcoming Festival of Britain. It became every town and city council's duty to celebrate the event no matter how small, as the nation was overflowing with 'festival fever' and eager to celebrate. The emphasis of the festival was on children; after growing up during the war years, it was now time for the youngsters to enjoy the spirit of the festival. Some Jarrow boys and girls were fortunate enough to be selected for a sightseeing trip to London, but all were involved in various activities at home participating in the many pageants, carnivals, competitions and street parties, organised by Jarrow's festival committee. Pictured here is Mayor Margaret Hood presenting the savings shield to Josephine Wilson in 1951.

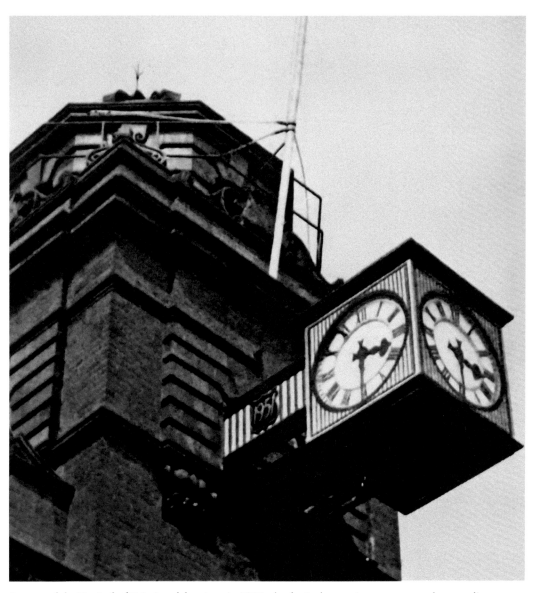

As part of the Festival of Britain celebrations in 1951, the festival committee commenced proceedings with a service of thanksgiving at St Paul's Church, which was followed by a dinner and dance in the town's Civic Hall. On another occasion Mayor Margaret Hood officiated at the opening ceremony of a sporting gala competition at the Metupa sports ground at Monkton. The opening of the Tyne Pedestrian Tunnel and the Festival Flats in High Street were to coincide with the town's contribution to the festival celebrations. The Town Hall was prepared for the provision, erection and unveiling of a 4-foot chiming clock as part of the festival celebrations. The £1,000 clock was financed with the remainder of the Surrey Fund. The clock can be seen here in 1951.

The town centre was brightened up considerably with beautiful flower displays in the grounds of Christ Church. Cash was also set aside as part of the town's renovations during the Festival of Britain celebrations exclusively for the refurbishment of Jarrow's extensive parkland. Facilities for children were painted and renovated, grassland, tennis courts, bowling greens and flower beds were tended to, and in excess of 300 trees were planted at Monkton Dene Park by children from each of the town's schools. Roger Farrell and local dignitaries can be seen here planting trees at Monkton Dene Park.

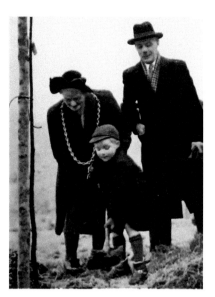

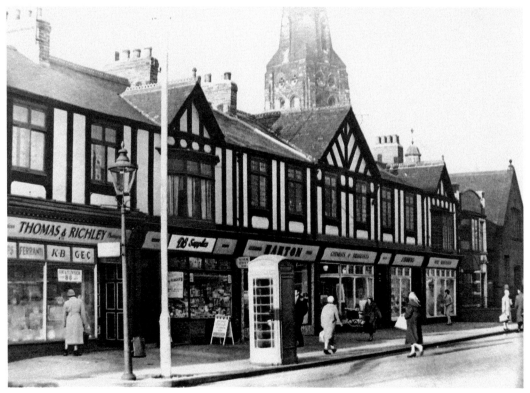

Thomas & Richley's showroom in Ellison Street, the town's leading electrical suppliers. During the early years of the 1950s, television was still quite scarce in Jarrow and deemed a luxury affordable to the few families who were fortunate enough to live in accommodation with electricity. During the decade most homes were illuminated with gas; it wasn't until later in the decade when houses were converted to, or being built and equipped with, the innovation of electricity, which opened up a whole new world of domestic appliances around the home.

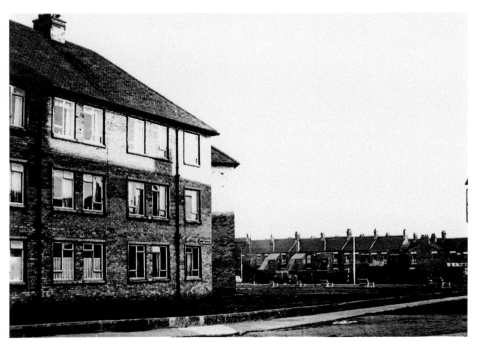

Above and below: As part of the council's housing and regeneration programme, new houses were beginning to appear almost overnight. This commenced with the construction of semi-detached dwellings at Primrose, followed by further developments at Monkton and Low Simonside. The building programme was interrupted on several occasions, but restarted after the war in 1945 with the construction of the Festival Flats (seen here) in High Street in 1951, Calf Close and Hill Park estates in 1955 and 1960, and concluding with a complex of houses, flats and maisonettes on the Market Square development site.

An extension of the borough of Jarrow was announced in April 1936 by a County Durham review order by Sir Kingsley Wood, Minister for Health. This extension was to include Monkton Village, Primrose, Hedworth and East Jarrow. Around the same time, during a period of county boundary adjustment, several acres of land east of Jarrow Slake were transferred to the county borough of South Shields. Pictured are the timber ponds at Jarrow Slake in 1950.

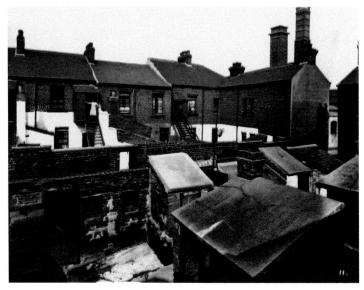

Backyard coal houses and outside toilets at the back of Ferry Street in 1925. The industrial slump that followed the end of the First World War brought further hardship not only to Jarrow, but to most of the poorer regions. Communities were hungry for work in a great industrial depression that was sweeping the country. The General Strike of 1926 produced further discontent and deprivation as miners and engineering workers demonstrated, often bitterly, for better wages and working conditions. For Jarrow, this hardship forced locals to gather 'sea coal' (a hard black slate substance), which burned with an amber glow when ignited. This was gathered from the beaches at South Shields, which was brought in with the tide. The harvest was sold for 2s (10p) per bucketful. Another source of fuel was 'duff balls' – handmade briquettes of coal dust gathered from the floor of the coalhouse mixed with quantities of soda and cement and formed into balls that were dried and used as an alternative to solid fuel.

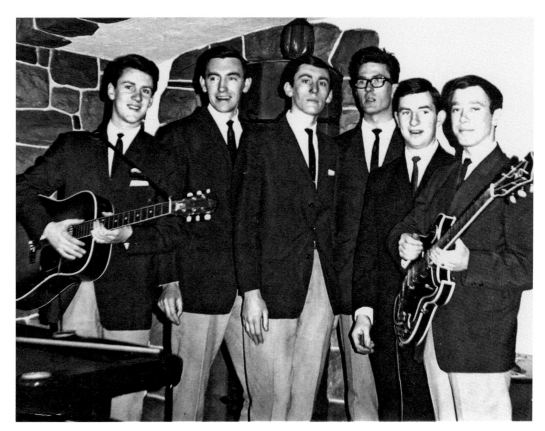

Above and opposite page: The 1960s was an eventful period in the history of Jarrow as popular music became all the rage. Elvis Presley spellbound teenagers by storming into the hit parade with 'It's Now or Never'. Meanwhile, three talented lads from St Bede's School recognised the new craze that was sweeping the nation by forming the aptly named The Crusaders, made up of Tom Quinn, Len Singleton, Dominic James and the late Ed Haws. They played weekly at St Mary's Youth Club. So popular were the band that in 1962 they were contracted to appear at nightspots at both South Shields and Sunderland as the resident band, playing three sessions a week. Initially the boys were an instrumental group, but as the Mersey sound burst onto the scene and two more musicians joined them, they became renowned for vocal harmony and were regarded as the 'Tyneside Beatles' for their covers of many of the Fab Four's compositions. The Spanish-themed La Strada nightspot at South Shields held the key to the band's further success as their reputation spread throughout north-east England. They played at the majority of the top venues in the region, sharing the bill with such greats as the Moody Blues, Lonnie Donegan, Englebert Humperdinck and the Shadows. In 1969, after resisting temptation to turn professional, the band broke up as its members found other interests. Rob, the lead vocal, continued his semi-pro singing career, and as late as 2017 was in the recording studio and touring the UK with his band The Hollywood Bees. But the legend of the band lives on in the memories of 'Jarra' lads and lasses who danced and gyrated to the golden tones of The Crusaders. Pictured in 1965, left to right: Rob Quinn, Len Singleton, Tom Quinn, Ray Burns, David Golden (road and tech manager) Brian Jeffreys and a 1960s La Strada bill of entertainment.

La Strada
CONTINENTAL CLUB

TONIGHT and SATURDAY NIGHT

Star of his own current radio programme

Val Doonican

Commencing SUNDAY and ALL NEXT WEEK

From TV's "Big Night Out"

Ray Fell

SUNDAY LUNCH DATE, 12 - 2 p.m.
& MONDAY EVENING SPECIAL

All the Club's usual amenities and in addition

THE CRUSADERS

MEMBERS NO COVER CHARGE ALL WEEK
GUESTS NO COVER CHARGE MONDAY - THURSDAY

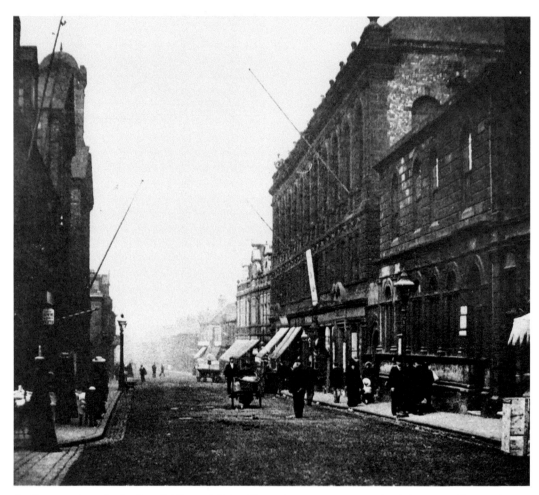

As fire tore through the Royal Albert Hall in Ellison Street in 1913, much of the upper floors of interior of the building were damaged beyond repair. However, the exterior of the building suffered only superficial damage. After years of extensive repairs and refurbishment to the building's interior it was converted into a billiard hall complete with twenty-one tables from 1916 to 1950. From this time the upper floors were utilised as a warehouse for a department store – Shephard's of Gateshead. From around 1970, the building was taken over by Comet Electricals. Today the building serves the town as the Job Centre. Pictured here is Ellison Street with the original façade of the Royal Albert Hall building to the right, 1899.

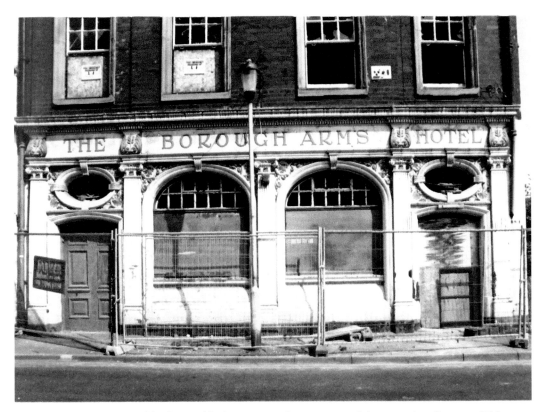

Many of the town's fifty-four public houses were brewery owned, but occasionally some did become available for auction and private enterprise. Local businessman and councillor John Rutherford realised the potential of the Turf Hotel in North Street in 1894. After considerable expense and refurbishing the building to exacting standards, he continued trading as a public house, which was renamed the Borough Arms and remained so until its demolition almost a century later.

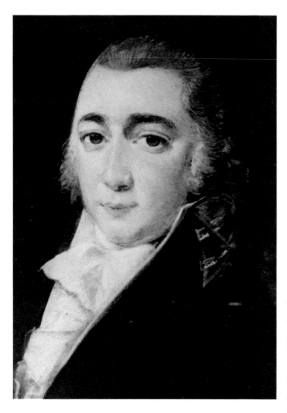

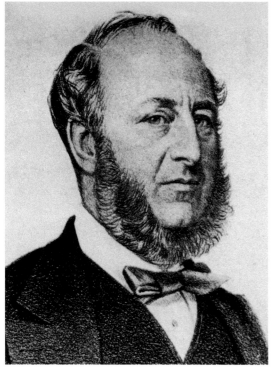

The earliest existence and identity of the town was dissolved around the ninth century when it was looted and pillaged by bands of Danish warriors during two bloody and deliberate invasions. The formation centuries later of the town we are familiar with today is attributed to the foresight of two dynamic industrialists: Simon Temple and later Charles Mark Palmer (seen here). These two individuals pioneered the coveted shipbuilding industries, of which Jarovians were so proud. It was the very lifeblood and backbone of the town for centuries.

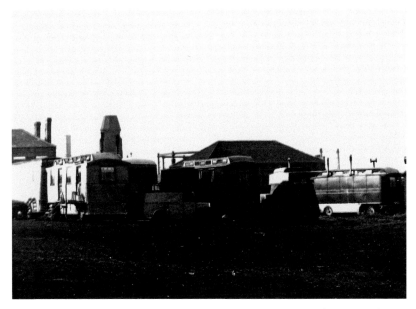

Showmen's caravans parked at the town's 'Pit Heap' in 1956. During the 1950s, the 'Pit Heap' became a temporary home for travelling showmen en route to Newcastle for the annual summer fair on the Town Moor. This event, billed as the biggest travelling fair in the world, attracted showmen from all parts of Britain and northern Europe. After the monumental event during Race Week, the showmen went their separate ways, earning a living at various venues nationwide.

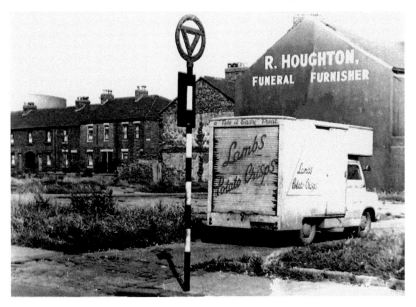

During 1887, Jarrow was serviced by four undertakers. The premises of Robert Houghton in Commercial Road were formerly occupied by funeral furnishers and cab proprietors W. & J. Hedley, who relocated to Western Road around 1910, similar to Messer's Burlison and Chapman, who both leased their carriages to the public upon request. Lamb's Foods Ltd was founded in Birtley, County Durham, but relocated to larger premises at Ferry Street, Jarrow, in 1950. Pictured here is Lamb's delivery van and Houghton's funeral furnishers from Ferry Street, 1956.

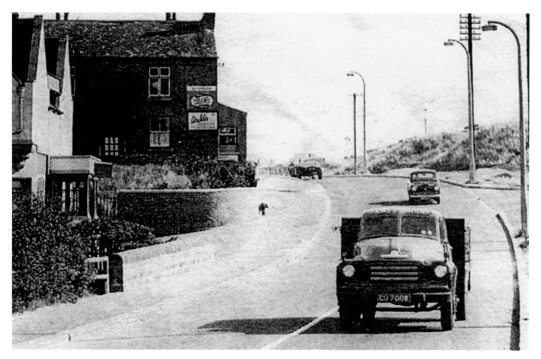

Above and below: These photographs of the 'Robin Hood Bank', as it was commonly known, date from 1952. With its awesome quiet, this part of Jarrow had a wonderful feel of the countryside about it. This scene of tranquil solitude was interfered with during the late 1950s and early 1960s when acres of pasture were excavated and unreservedly scarred to the expense of a dual carriageway, carrying what seems like the endless stream of traffic that now passes this way.

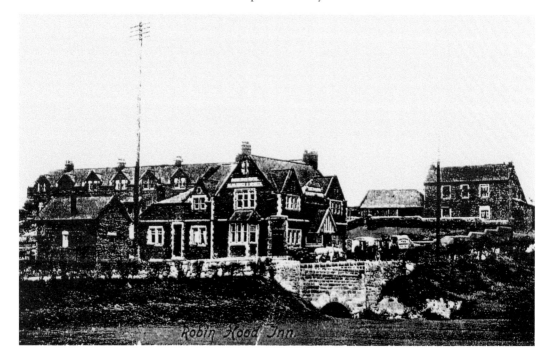

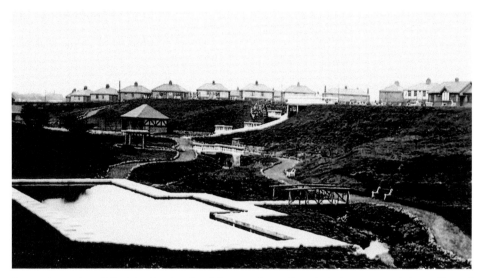

It was the genius of Sir John Jarvis who did so much for the relief of poverty and the welfare of Jarrow folk during the severe depression of the 1930s. One of his missions was to transform acres of pasture solely for the purpose of recreation. The parkland was named in honour of Sir John. Because of its location, the park is known by a more familiar name today – Valley View Park. This image of the park dates from 1956.

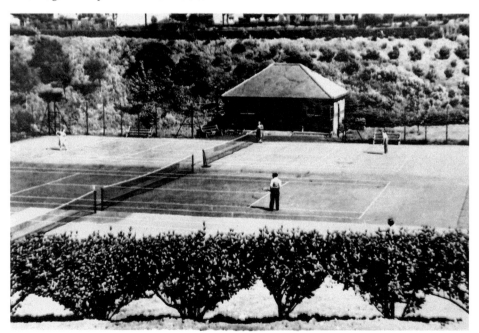

Another image of Jarvis Park dating from 1956, this time showing the well-tended tennis courts and pavilion. The 20-acre parkland created in 1935, similar to others in the town, were magnets for children and adults for many years. They were full to capacity with picnicking families during the long hot summer months back in the 1950s and 1960s. In recent years the popular paddling pool was disbanded in the interests of health and safety, and the tennis courts and bowling greens are no longer a feature of the park due to insufficient local council funding.

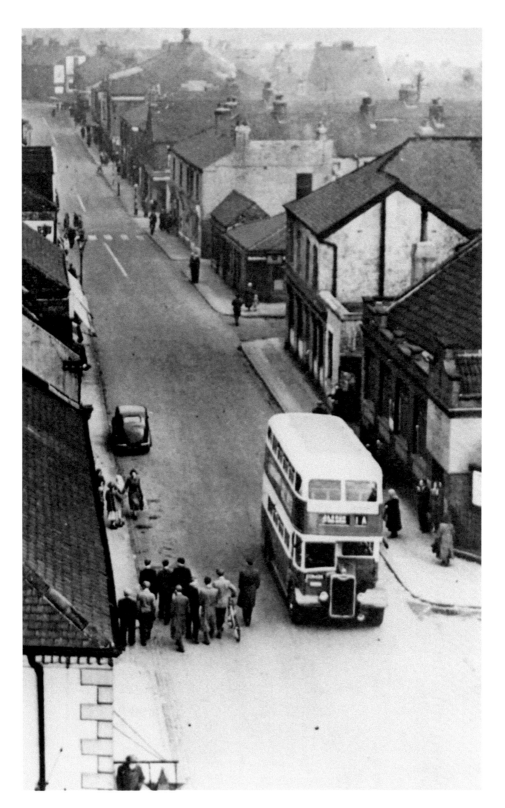

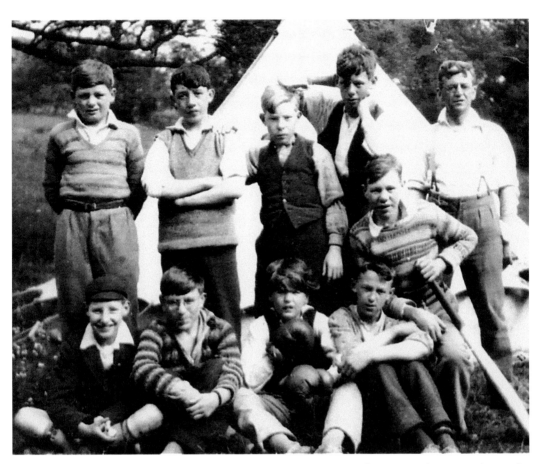

Above: With little or no money in their pockets, Jarrow boys were adept at providing entertainment for themselves. One simple pastime enjoyed by the adolescents during the school holidays was camping. Tents were pitched anywhere the boys seeking adventure could anchor them down. Among the favourite venues was Harrison's Field, close the River Don, though this was nothing much more than a trickling stream back in the 1940s and 1950s, a time when one of the simple pastimes was fishing for hours, the end result being a prize of just half a dozen sticklebacks.

Opposite: This image of Grange Road was taken from the bell tower of the Town Hall some sixty years ago, showing precisely the changing face of central Jarrow. Nothing survived as the town planning department and wandering bands of demolition men razed the former town and its buildings to the ground in a short space of time. The old Northern General Transport double-decker pictured in this old image, service 1A from 1956, operated between Jarrow and the recently completed South Leam estate.

M. JENNINGS
(Proprietor: T. RICHARDSON)
81 LULWORTH AVE., JARROW. TEL. 89-8093

Weight Ticket for Delivery of **Solid Fuel**
over Two Hundredweights.
All communications to be addressed to the above.

22nd Sept. 79.0

To Mr. *P. Hare.*

Take notice that you are to receive herewith of **Solid Fuel:-**

Tons	Cwts	Qrs.	Type	£	s	d
	5	0	Nuts	3	0	0

In...5...sacks each containing...1...cwt.

Cash Received £ : :

...Agent

Led by............

Received by............
No second order supplied until first has been settled.

This document must be handed to the buyer before any of
the solid fuel is unloaded from the vehicle. If it cannot be so
handed over by reason of the absence of the buyer, it shall be
left at some suitable place on the premises where the solid
fuel is delivered.

Signature of Consignee

DEAN PRINTING WORKS

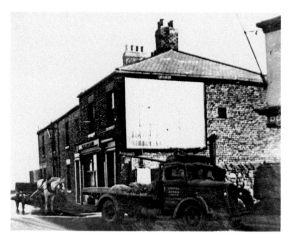

Horse-drawn and handcarts were a
common site in many towns and villages
up until and including the 1950s, usually
making door-to-door deliveries of all
manner of produce from milk, butchery
and greengroceries to coal. Horse-drawn
and horsepower stand nose to tail in
this 1956 image taken in High Street of
two differing forms of coal delivery from
Hudson & Sons and Jennings, who were
the towns two principal suppliers of
domestic fuel up until the closing years of
the 1970s, when 5 hundredweight of the
best coal cost just £3.

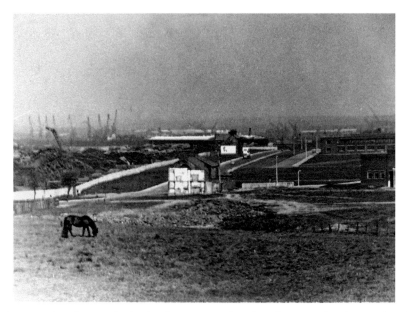

A single-roomed Bede Parochial School was erected within the grounds of St Paul's Church in 1840, with a similar-sized establishment constructed close by. Little was recorded of the day-to-day running of the school, with the exception that it was set up by Meases Chemical Works who dominated this part of East Jarrow during the latter part of the nineteenth century. The school was used solely for the education of employees' children.

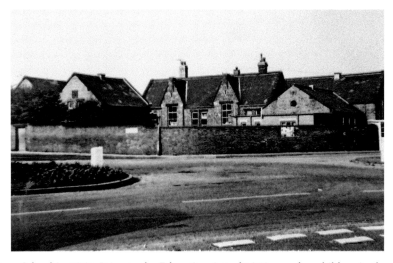

Bede Burn School in 1965. Prior to the Education Act of 1870 very few children in the country received any form of organised education. From this time bylaws had been created and approved by the governing bodies, making school attendance compulsory for all children. The governors of the school board created temporary classrooms in buildings until permanent and adequate facilities became available. In April 1873, Jarrow led the country by opening the first permanent board school – Jarrow Grange. This was followed in the same year by the Monkton School, which later became Bede Burn School. Although grammar and private schools were in existence at the time they were reserved for the middle and upper classes, as the working classes could ill afford the necessary fees.

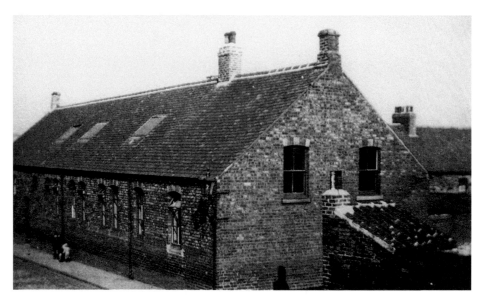

In 1872, two years after the implementation of the Education Act, another one-roomed school – St Bede's – was provided for boys, again close to St Paul's Church at Low Jarrow. When the school opened the question was raised as to why it was built so far away from the main body of the town. This was considered to be the ideal location and thought to be central to all concerned, as children from close by Tyne Dock residing on the opposite side of the bridge spanning the River Don were to be educated here also.

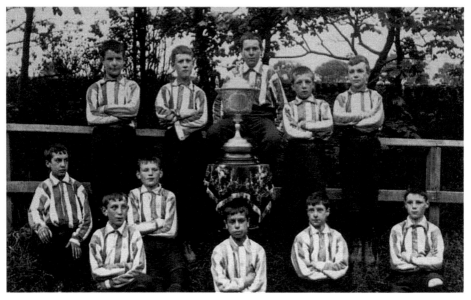

As early as 1888 the schools and clergy of all denominations were keen to organise inter-school competitive football teams. The first team to be organised was Jarrow St Bede's Hibernians, which was formed in 1890. From 1895 the team won the coveted Sambotee Cup three years in succession. (Sambotee was an Indian company specialising in the importation of tea.) By 1920 a footballing committee had been formed, which appointed Bill Rice as coach. Bill's expertise successfully led the team to many victories. Pictured are the original Hibernians team from 1895.

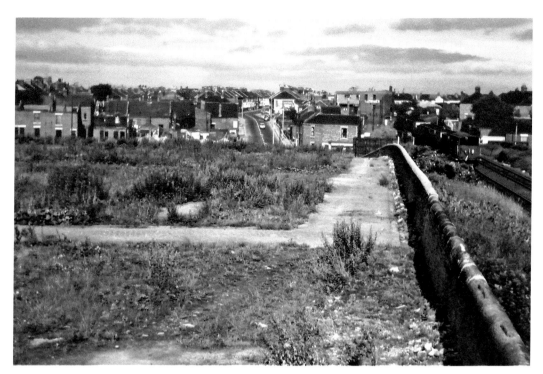

Victor Street clearance area, 1970.

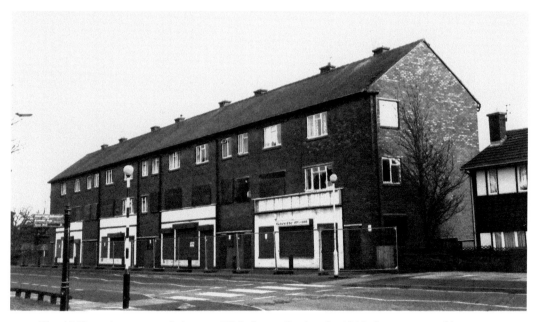

The 1950s maisonettes and shops at High Street. During the 1930s Jarrow was subject to a greater rate of unemployment than any other borough in the land. The town began to epitomise the unhappy state of affairs endured by so many and for so long. But nothing lasts forever – financial depressions and wars included. The post-war years saw a general improvement in the wellbeing of the town and its people, as houses and schools were being built to meet the requirements of an ever-growing community.

The first management committee meeting of St Bede's Parochial Men's Club (pictured) took place in 1947, when Felix Sullivan was appointed chairman, presiding over committee members. During the ensuing years many charities benefitted from events staged at the popular club in Chapel Road. Eventually the ageing building was showing severe signs of decay and neglect in certain areas, which resulted in the club relocating to the former Jarrow & Hebburn Co-operative offices in Albert Road until the club was disbanded in 1995.

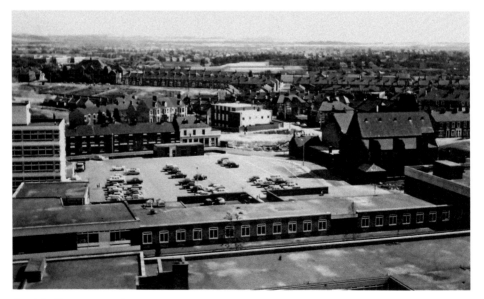

Arndale Centre car park.

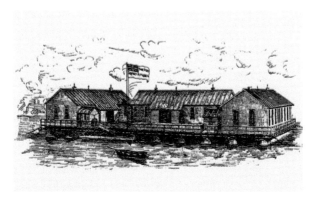

The joint committees of the local government and Port of Tyne Sanitary Authority appointed Dr William Whammond public vaccinator. This service was to work chiefly alongside the recently approved floating hospital, which had previously been conveniently moored on the River Tyne at Jarrow. The purpose of the facility was to contain and eradicate infectious disease brought in from oversees aboard the many merchant vessels that passed this way when Jarrow was one of the major ports on the river. The quarantine hospital (pictured) was built at Gateshead by boatbuilders Wood & Skinner and floated into position at Jarrow Slake in August 1886, where it protected the town against possible infectious disease until the scheme was abandoned in 1930.

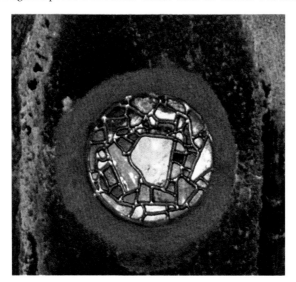

During the seventh and eighth centuries, close to St Paul's Church, there were allotments and workshops. The gardens were exclusively used to grow vegetables for use by the 600 Benedictine monks from the monastery close by. Stained glass was manufactured in small quantities along with metalwork in the crudely built workshops – both for use in the church and monastery. Close by on the same site, though rather primitive, there was a facility for the tanning of hides to produce the vellum for use in the scriptoria at the twin monasteries at Jarrow and Monkwearmouth. Benedict Biscop is attributed with bringing glassworkers from the Continent to manufacture the coloured window glass on a much larger scale. The colour pigments were crudely extracted from a variety of substances, including various metal oxides and minerals. The glass was originally blown, flattened and cut into small pieces and fitted together to create small but effective windows. The tiny and ancient window pictured here, the earliest example of Anglo-Saxon stained glass in Europe, is on display at St Paul's Church, Jarrow.

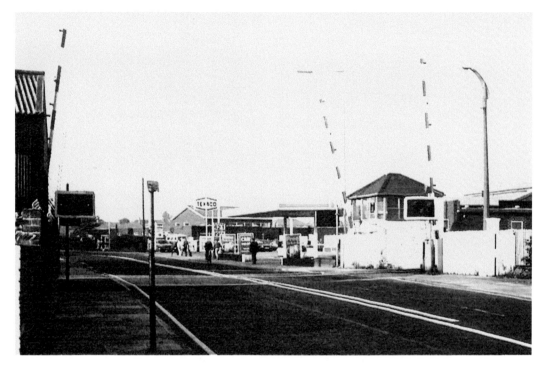

Above: Monkton mineral line was originally constructed as a colliery railway. It was built for the wealthy landowners the Bowes family, who had interests in coal mining, the production of natural fuel and the railways for the transportation of coal from the mines in the Durham coalfield. The earliest section was designed and built by George Stephenson as early as 1826, making it one of the world's first modern railway systems. Upon its completion in 1855, the line covered an area of 15 miles, which remained intact and operational until 1968. From this time only the last 3.5 miles of track were serviceable, which was owned by National Coal Board, from the coking plant at Monkton to the riverside location of the staithes until its closure in the 1980s. Pictured is a level crossing on the Bowes line at Albert Road in 1960.

Opposite: Coal loading at the staithes and construction of the conveyor system in 1935. The Tyne Improvement Commission commenced construction work on the Jarrow coal staithes in 1933. It was completed by 1936 and was officially opened by the Duchess of York in 1936. The coal arrived by train from the Durham coalfields to a bunker yard and a coal washing facility, situated behind the former site once occupied by Simpson's Hotel. The prepared fuel was then transported via a network of overhead conveyor belts to waiting vessels at the loading bays at the staithes on the river for transportation.

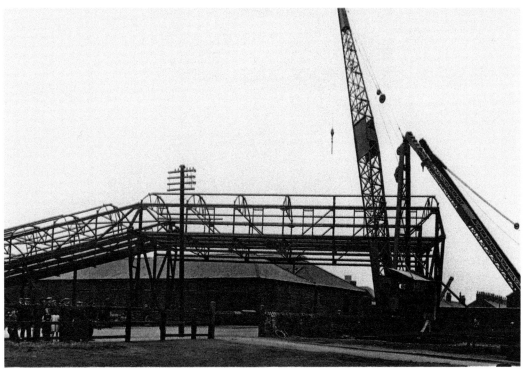

49

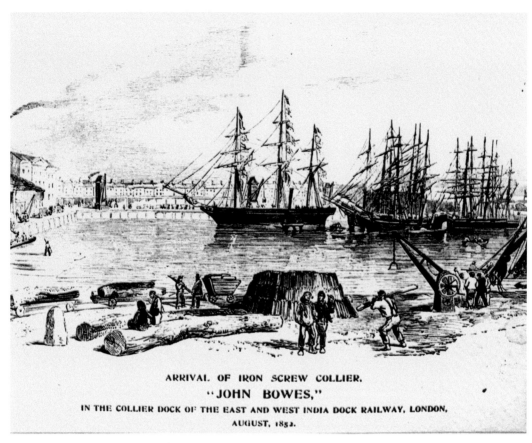

ARRIVAL OF IRON SCREW COLLIER,
"JOHN BOWES,"
IN THE COLLIER DOCK OF THE EAST AND WEST INDIA DOCK RAILWAY, LONDON,
AUGUST, 1852.

There is evidence in Durham Cathedral that coal had been shipped from Jarrow in small quantities as early as 1600. But the practice of exporting the fuel to the south of the country commercially began in earnest by Simon Temple from his notoriously dangerous Alfred Pit around 1803, aboard the collier *Fox*, to the lucrative markets in London. In the ensuing years there was a steady but modest increase in coal transportation from Jarrow up until 1852, when Palmer's launched the *John Bowes* (pictured). This vessel, the world's first iron screw steam-powered collier, had the capacity and velocity to complete the round trip to London in five days – a trip that usually took two months. After a working life of an incredible eighty-two years, she sank off the coast of Spain under the name of *Villa Selgas*.

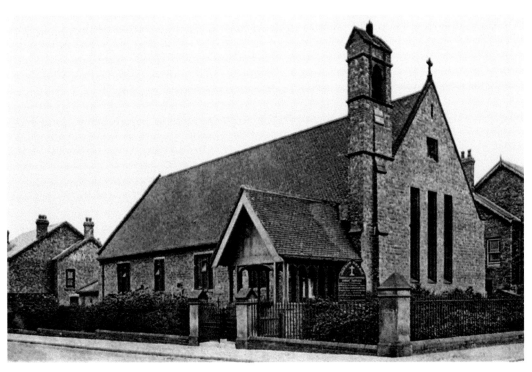
Church of the Good Shepherd, Surrey Street, 1912.

Mayor Councillor Frank Dixon entertaining senior citizens at the Civic Hall in Ellison Street in 1969.

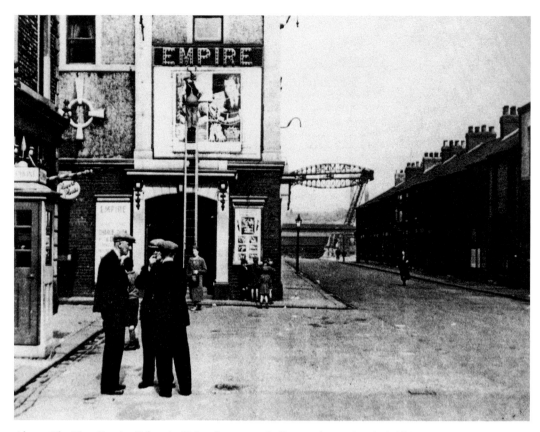

Above: The New Empire Palace in Union Street was built as a theatre in 1912. This we can ascertain by the fly tower at the rear of the building. The fly tower was used to store theatre backdrops in an upright position. By 1925 it was renamed the Empire Picture Hall, but continued to present live theatre and variety acts. In 1926, the 800-seat theatre was refurbished and refitted with the latest technology in sound and film projection systems and renamed the Empire Cinema. Revolutionary cinemascope was fitted in 1955. Due to the popularity of television during the 1960s cinema audiences dropped dramatically, which brought about the cinema's closure in 1970. It did, however, have a new lease of life as a bingo hall until 2001, when the building was demolished.

Opposite: The former Theatre Royal in Market Square opened in 1866 and attracted top-billing performers from the world of theatre and entertainment. In 1894, and as the theatre went from strength to strength, extensive alterations were carried out by Newcastle architects Henderson & Hall. By 1898, the theatre wondered into the wonderful world of cinema, screening silent films as part of its attractions up until the end of the First World War, but continued with live performances until its closure in 1941. The building lay derelict for twenty-one years until its demolition in 1962, the spoils of which went to create Lindisfarne roundabout. The accompanying images are from 1940 and 1962 respectively.

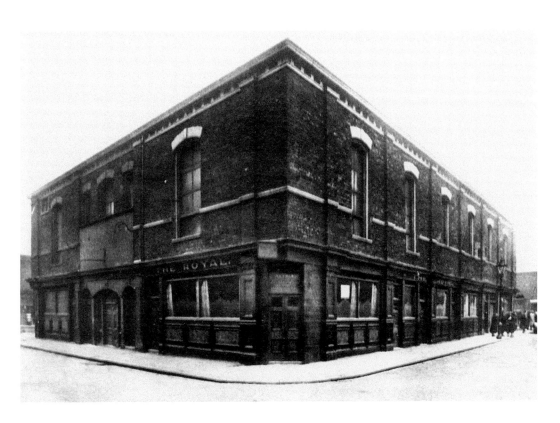

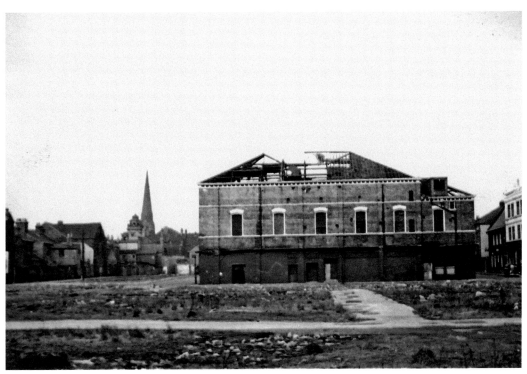

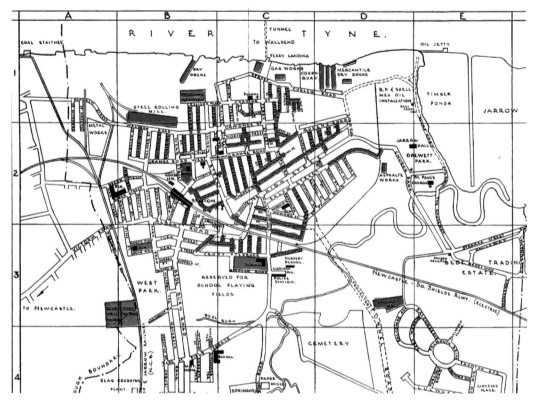

Above: Much has changed in the central area of the town centre since this street map was published in 1950. Long gone are row upon row of terraced houses, together with many churches, schools and public buildings. Just how many fell victim to the demolition experts, and how much of the town was 'lost', are highlighted in red in the accompanying image.

Opposite: Not quite an aerial photograph, but nevertheless a perfect vantage point to record and demonstrate how the townscape has changed in the past fifty or so years. This image taken from Ellen Court in 1967 when the Festival Flats were still habitable and in reasonable condition. During the 1970s, the former luxury flats from 1952 deteriorated rapidly after several bouts of vandalism and were consequently demolished as a result in 1982. All that remains in the foreground of the photograph is the Salvation Army Citadel to the bottom right. The second image is looking in an easterly direction towards the Mercantile and storage tanks of the Shell oil terminal.

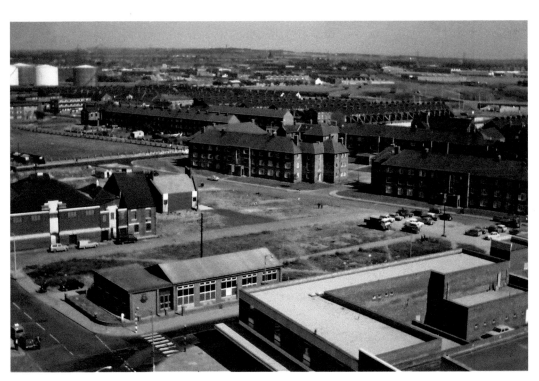

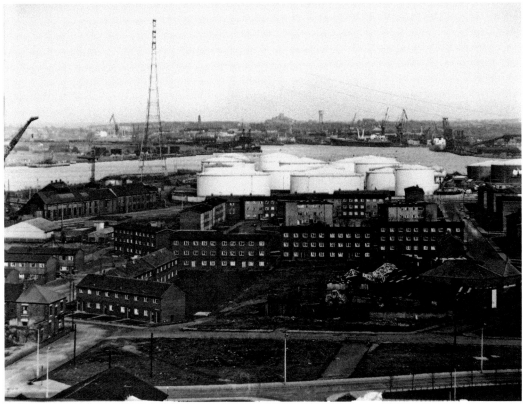

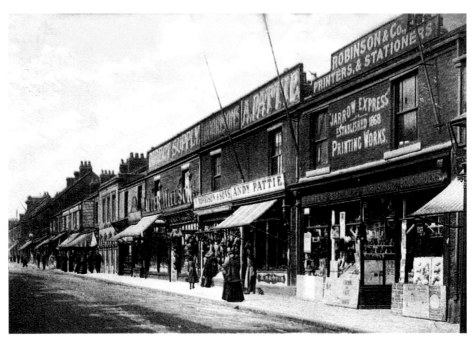

Ormonde Street was one of the town's major thoroughfares. It carried the tram service to its terminus at Western Road from 1906 to 1929, when the service was discontinued. This 1912 photograph is typical of the period. The shops were demolished during the 1960s, as most of the businesses relocated to brighter new premises within the Arndale precincts.

Members of the Jarrow branch of YWCA from 1950.

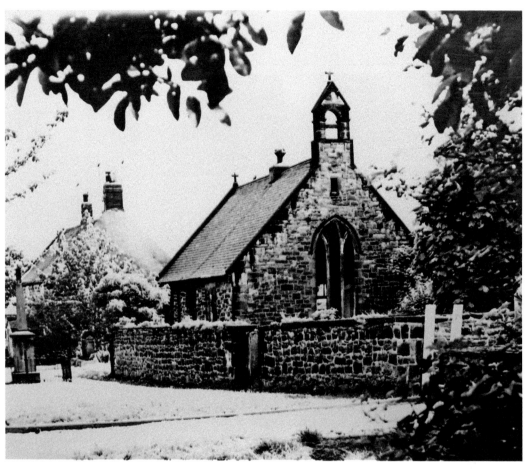

The church of the Venerable Bede, pictured here at Monkton Village. This former little ancient church maintained its status as a chapel of ease until the 1960s. Sadly, during the 1970s, the building was abandoned and fell into a state of disrepair. Eventually, the listed building was saved from total destruction, refurbished and converted into a fine residence. The war memorial to the left of the photograph was erected in 1921 as a lasting memory to the casualties of Monkton, who fell during the First World War.

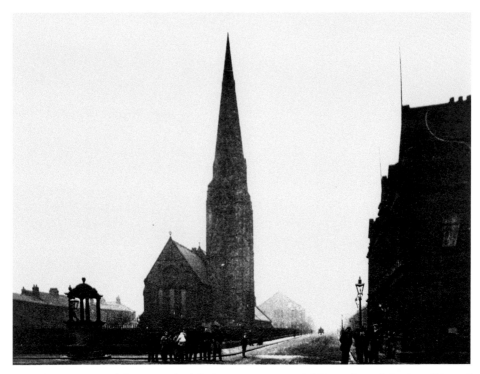

With the exception of the removal of the Longmore Memorial Fountain and the demolition of the houses behind it, the scene remains exactly as it did when this photograph was taken more than a century ago. Christ Church (centre) was erected in 1869, was just one of seventeen such establishments at that particular time. Today just three of the original seventeen within the town centre remain standing.

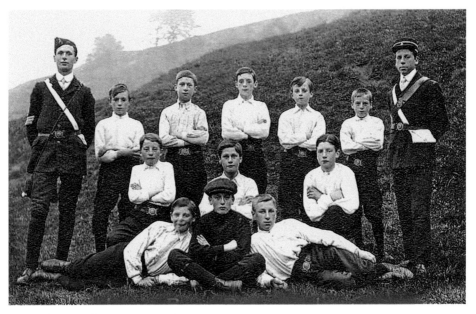

Jarrow division of the Boys' Brigade, 1908.

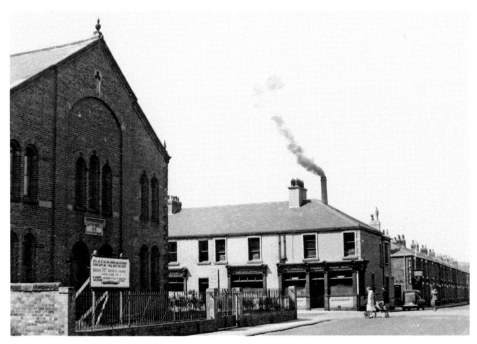

Above and below: The Grange Road Baptist Chapel is one of only three places of worship remaining within the town centre. When the 720-seat church was built in 1879, the church was accessed from an entrance in Clayton Street. During the 1980s this part of town was subject to major refurbishment with the demolition and reconstruction of the Palmer Memorial Hospital. Very little has changed since the upper photograph was taken in 1955, with the exception of the demolition of the terraces in McIntyre Street to the right. The building in the centre of the image was the former offices of the Tyne Commercial Building Society; today it is a solicitor's practice. The lower image from 1979 shows early construction work on the hospital.

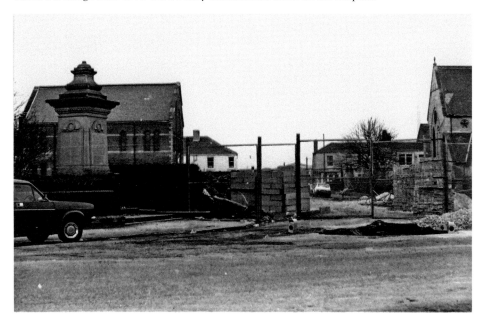

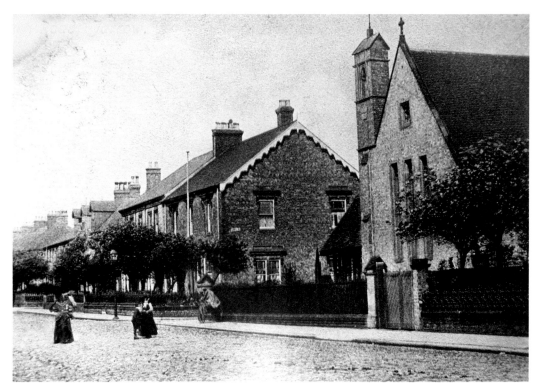

The accompanying picture postcard of Park Road is one in a series of hand-coloured images of Jarrow, published around the turn of the twentieth century. The large Victorian dwellings were constructed towards the end of the nineteenth century. The building to the extreme right was the Chapel of the Good Shepherd, which was demolished during the 1970s and replaced with private housing.

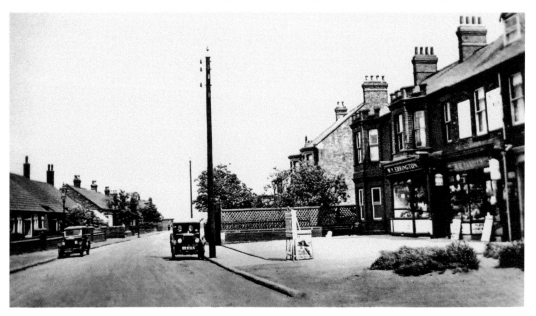

Wood Terrace, Monkton Village, 1920.

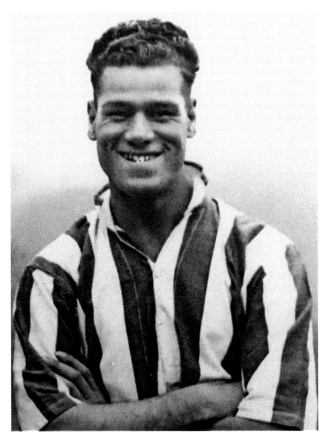

Born in Jarrow in 1910, Danny Edgar (pictured) was educated at St Bede's School in the town. Similar to most of his generation, Danny was content kicking a ball around the back lane behind the family home in Western Road. His enthusiasm for football was fuelled when he was chosen to play for St Bede's junior boys team, and eventually the senior boys. It was while playing for this league that his ability was spotted by scouts who travelled the length and breadth of the country seeking out footballing talent. Just as Bournemouth AFC were showing an interest in his ability, he received word to attend Sunderland's Roker Park for trials. During these trials he played right-back against Scottish International Jimmy Connor when he suffered an injury. Convinced he had a promising career ahead of him, SAFC sent him to Walsall for recuperation. Upon his return some months later, Danny signed for Sunderland in August 1930, displaying his ability and versatility playing in many different positions. In 1933, he played to a record-breaking crowd of 75,000 against Derby County in the sixth round of the FA Cup. By 1935, he had signed for Nottingham Forest, playing in the right-back position where he was thought to be best placed because of his stamina, ball control and kicking power. Danny Edgar played alongside some of the country's greatest footballers of the time – striker Bobby Gurney and inside-forward Raich Carter among them – travelling extensively and internationally representing Sunderland. But the modest man often played down his remarkable footballing career, even though he made in excess of fifty appearances for the club. Cartilage injuries ended the fullback's career in 1938, the year he married Angelina Rea, who he met at her family's ice-cream parlour in Grange Road in the town centre. They were married at St Bede's Church, Jarrow, and had four children together: Anthony, Dolores, Eugene and Christine. They celebrated fifty-two years' wedded bliss until Angelina's passing in 1990. Danny passed away exactly one year later in 1991. Without doubt, a great success story of one of the many talented football professionals Jarrow has produced.

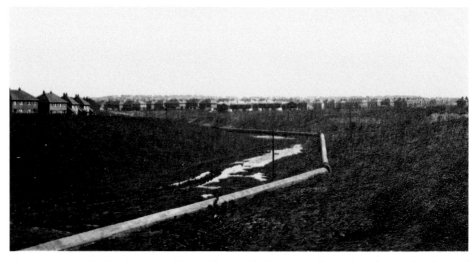

Plans for a tunnel under the river solely for the use of vehicular traffic were in place and authorised by both councils north and south of the River Tyne, as part of the post-war road improvement act. Work commenced on the £8.5 million Tyne Tunnel in 1960, linking it with a further £3.5 million network of dual carriageways and approach roads, which became fully operational by 1967. The construction of the approach road on the southern side severed a valley at Simonside, which caused the rerouting of the 'white pipe', as it was familiarly known (pictured), creating an alternative route for the sewage it carried.

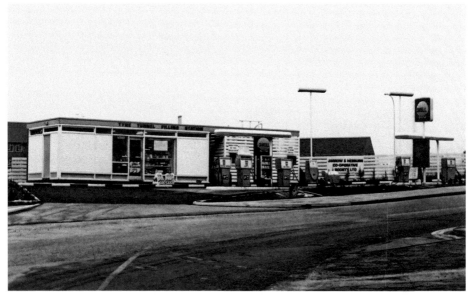

While the storage tanks in East Jarrow were capable of storing up to 4 million gallons of petroleum spirit and domestic fuel oil, there were only ever two filling stations in the town centre during the 1950s: Rounthwaites in Edward Street, and the Co-op garage in Albert Road. Compulsory purchase orders forced the two companies to seek new premises, and Rounthwaites relocated to South Shields. The Co-op petrol station, however, didn't appear until the early 1960s. The accompanying photograph of the Co-op filling station dates from 1967, when four-star fuel was 3s 2d (17p) per gallon.

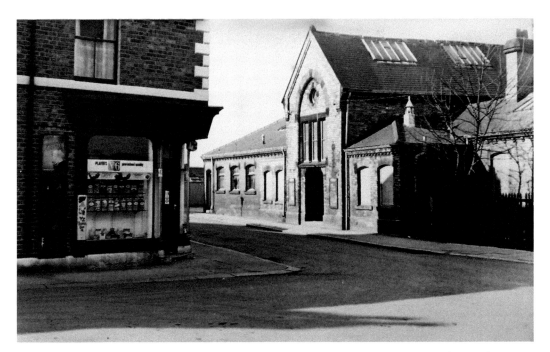

Above and below: Radical changes became necessary to streamline the country's rail network as more and more companies transported their freight by road as a cheaper alternative. This was to significantly reduce the need for manned stations, which included passenger ticket offices. Passenger and freight trains had operated in and out of the Grant Street station since its opening in 1872. This transformation was to leave the Jarrow platforms bare of all buildings with the exception of two simple structures to shelter from the elements. The introduction of the Tyne & Wear Metro, in 1982, changed the appearance of the simplified station yet again.

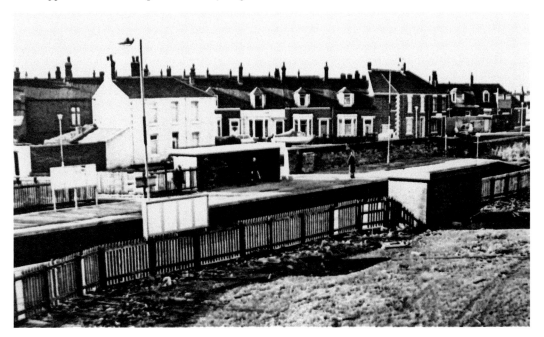

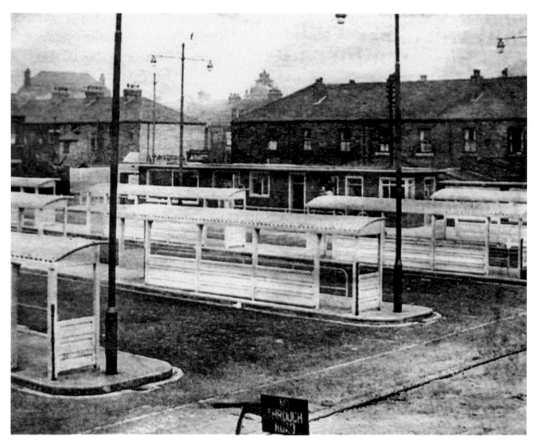

By the 1940s people were becoming more dependent upon public transport, as fleets of buses and destinations were growing daily. Newcastle and South Shields operated a trolleybus service, an electric system powered by overhead cables. This was a clean, swift and economical way of getting around, but limited to inner cities. The 'trolleys' were discontinued during the 1950s as the motorbus became the preferred mode of transport. Jarrow bus depot came along in 1954, to a convenient site within the town centre where it remained until 1990 as more passengers used the Metro. The old depot was demolished and the site used to build a supermarket, which incorporates a scaled-down bus depot. The 1954 bus depot is seen here nearing completion.

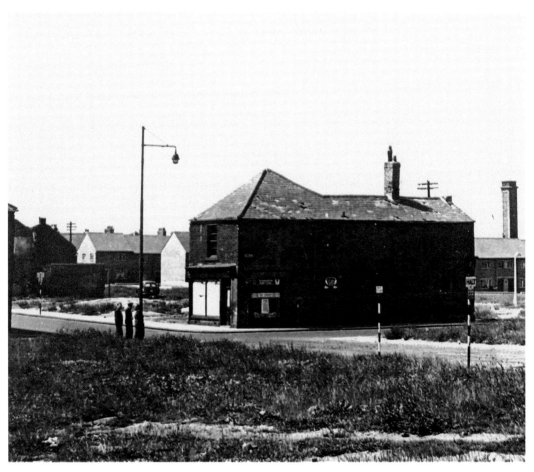

Another fine example of some of the town's tumbledown buildings is evident here in this 1950 image of the junction of Ormonde Street and Ferry Street showing Rose's chemist shop. James Dudfield Rose was responsible for recording everyday life in Jarrow around 1900, through the lens of his old wooden plate camera. However, the accompanying photograph from James Hunter Carr followed in Rose's footsteps, recording images of the town during the 1940s and 1950s.

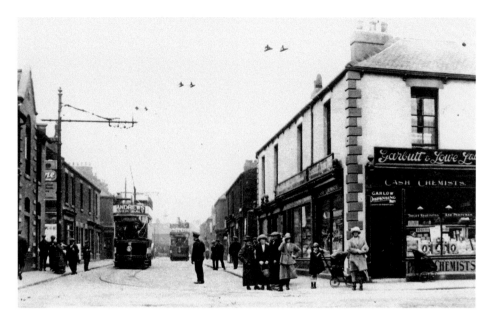

When this photograph of Staple Road was taken in 1925, there were six pharmacists dispensing drugs in Jarrow. Garbutt & Lowe, pictured here at the junction of High Street, was the town's major supplier of pharmaceuticals. Other popular druggists were Messrs Rose and Penman, both having premises here. The building to the left was built in 1919 for pork butcher Henry J. Abel, who resided on the premises with his family up until the 1960s. Today this former thriving thoroughfare is little more than a shortcut to the town centre.

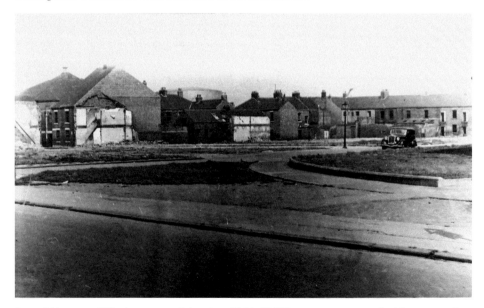

It would be most difficult to get one's bearings if this 1957 image was presented without a caption, as it bears no resemblance to how it looks today. The photograph was taken from Monkton Road and shows the remains of the terraces in Burns and Gray streets. The land lay barren for several years until the post office and lending library were built during the late 1960s. The Community Centre came along later in 1977. Today the site is occupied by a supermarket car park.

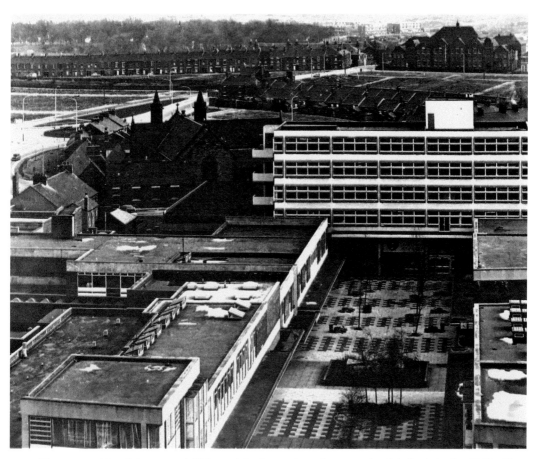

The partnership of Arnott and Chippendale dreamed up the name Arndale back in the 1950s. They became pioneers of the construction of 1960s-style inner-city shopping precincts. In 1953, Jarrow was chosen as the first, and was the flagship of the company's traffic-free shopping centres. A central four-storey building was constructed in 1962 at the foot of Viking Precinct. The lower floors of the building were utilised as offices, while the upper floors were given over for use as an Italian-themed nightspot – Club Franchi.

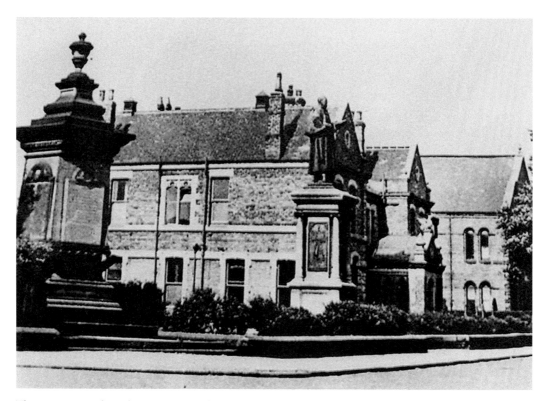

The war memorial in Clayton Street to the left of this photograph was presented to the town in 1921, as a gift to the borough from the management of Palmer's shipbuilding company, commemorating those who lost their lives in the First World War. The statue of Sir Charles Mark Palmer, founder of the company, was sculpted by Albert Toft and erected within the grounds of the memorial hospital Palmer built in memory of his first wife, Jane. During the 1970s the bronze statue was relocated to a site overlooking the River Tyne. In 2007, it was relocated once again, this time to a site in Grange Road overlooking the Town Hall.

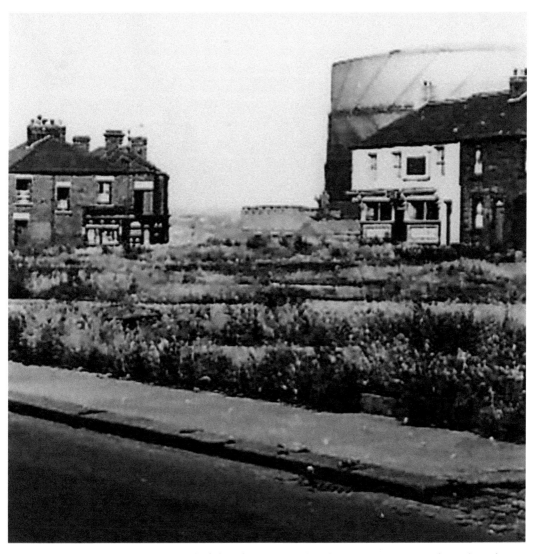

The wasteland in the foreground of this photograph taken from Ferry Street was formerly a clay pit until 1850. From this time the area was occupied by the terraced houses of George Street and Alfred Street. When these properties were demolished the land lay desolate for many years until the 1970s, when it was used for the construction of St Peter's Church of England School. This was demolished in 2005, as the land was required for further development. The gasholder in the background was dismantled in 2017.

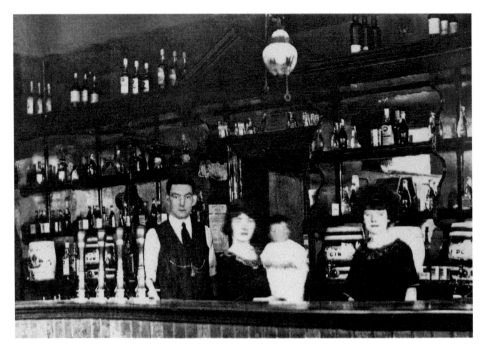

Above and below: When this photograph of publican John Rafferty and his family was taken in the Staith House in Tyne Street in 1925 it was expected that the host would be appropriately dressed in white shirt and tie. Today the emphasis is on comfort and the range of ales on offer. Long gone are the days when a Snakebite meant exactly what the name suggests, and a Black Russian was someone from overseas. This all seems light years away from what publicans had to cope with when lager and cocktails were unheard of, and the most complex drink on offer was very likely to be a port and lemon.

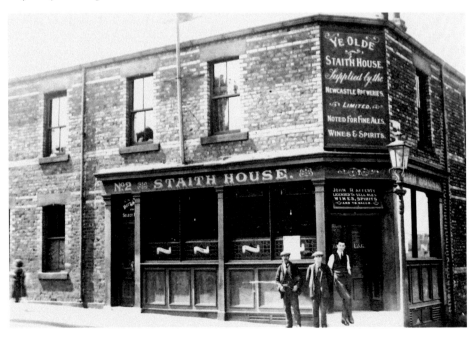

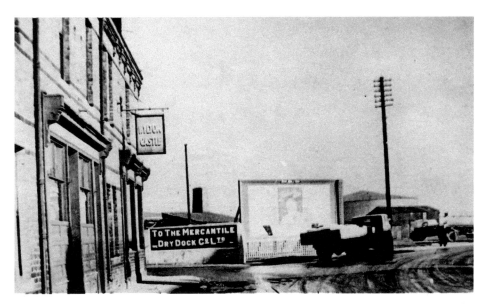

High Street was largely given over to housing, having in excess of 400 dwellings. This made it the longest-inhabited street in the town up until the 1950s. It began at Monkton Road, continuing in an easterly direction and ending at the Hylton Castle Hotel. Church Bank was beyond this point, which included Cuthbert Terrace. Curlew Road, to the left of this photograph from 1949, gave access to an oil terminal and the Mercantile Dry Dock Co. A ring road around the perimeter of the town centre came along in the 1960s, linking the Tyne Tunnel approach roads with the A19 and A1.

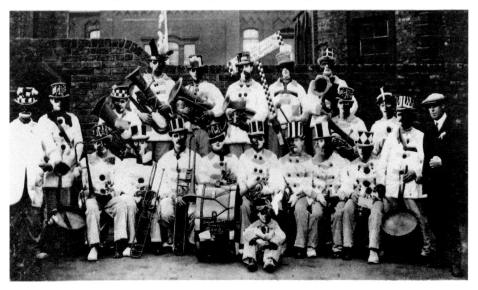

Scratch bands were fashionable during the 1920s and 1930s when the town came alive with carnival during the summer months. Bands similar to The Jarrow Savages, the flamboyantly attired King Tuts and the Pirate Band from the Forrester's Arms entertained thousands during the dark days of the depression, as the carnival wound its way through the cobbled streets from the 'Pit Heap' to the West Park. There was dancing and competitions and prize giving for best-dressed entertainers concluded the day's entertainment. This image of a carnival band assembling in the grounds of the Ellison School dates from 1923.

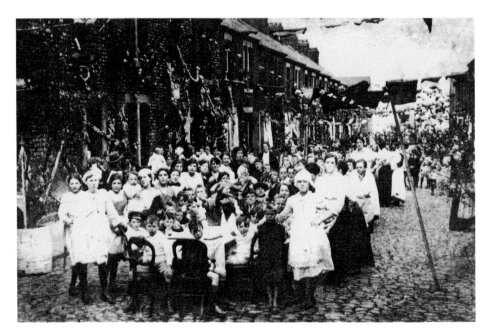

The Union flag, banners and bunting sway gently in the summer breeze, as wives, mothers and children wait excitedly for the safe return of their loved ones with a celebratory street tea party. This photograph was taken in Nansen Street in 1919, and is another classic example of the community spirit that Jarrow had in abundance.

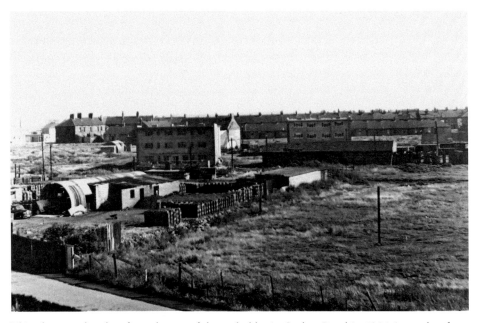

This photograph, taken from the top of the gasholder in Curlew Road in 1956, is another from the camera of James Hunter Carr. The penned area to the left was Simpsons brick works, who specialised in the manufacture of breeze blocks for the building industry. Close by were Jarrow cricket ground and pavilion, Sea Cadet headquarters, Lamb's blacksmiths shop and an Acetylene works, which fell victim to a major explosion in 1928.

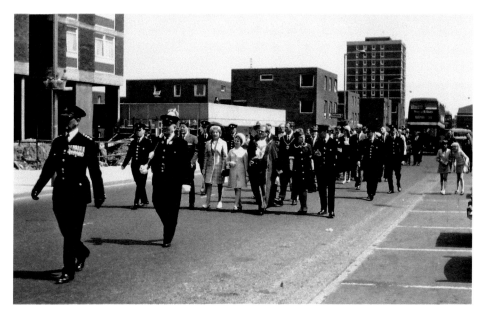

Another of the town's traditions that disappeared during the 1970s when Jarrow lost its identity as a borough and became incorporated into the metropolitan borough of South Tyneside was the annual Mayor Sunday parade. This event, which attracted huge crowds, celebrated the election of a new mayor for the forthcoming year. On this occasion the mayor and mayoress, Councillor and Mrs George Goldsborough, and council officials, pictured here in Grange Road in 1970, proceeded to Christ Church for a thanksgiving service.

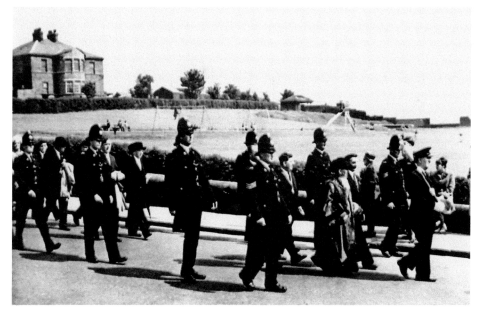

Once again, another lovely picture from a bygone era, and another of the Mayor Sunday procession. This time Mayor Elect Councillor Ralph C. Sparks, town clerk Gerald T. Noon and civic dignitaries follow the town mace bearer to St Paul's Church for a thanksgiving service. This photograph was taken on Church Bank in June 1965.

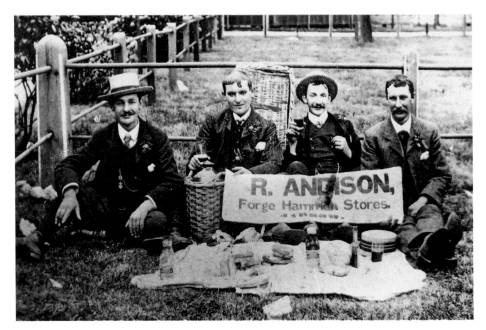

Above and below: Straw boaters and Sunday best attire were compulsory for management and senior sales assistants of Robert Andison & Co., wine and spirit merchants, for their annual summer outing to the races. Andison's, of the Forge Hammer Stores in North Street, were prominent in Jarrow as mineral water manufactures, supplying the region's retailers and breweries in earthenware bottles and flagons, similar to those in this evocative photograph from 1912.

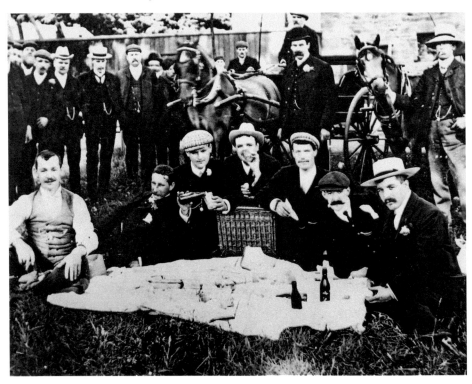

Bede Burn Road, 1964.

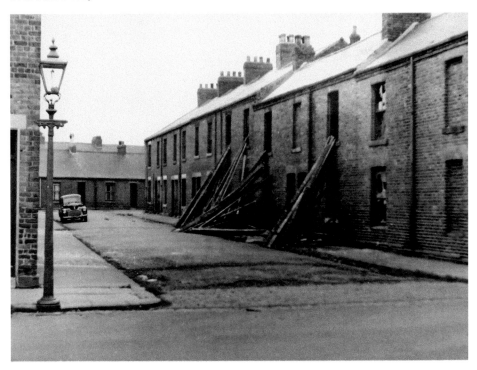

During the 1940s and early 1950s, the accommodation in the Queens Road area of the town was nothing less than deplorable. Vermin-infested properties and overcrowded conditions were not uncommon. Many of these properties were blighted with severe and uncontrollable dampness, which was largely to blame for the poor state of health of many of their occupants. Pictured here is the demolition of substandard property in Knight Street in 1955.

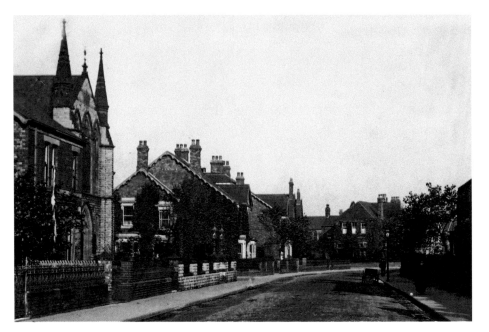

Prior to the turn of the twentieth century, a bylaw introduced by the Corporation prevented the construction of public houses on the southern side of the town, namely the area beyond the railway station in Grant Street. An extract from the document reads: 'All such establishments were to be contained within the boundaries of the town centre, with exception bestowed upon the major political parties and private members establishments.' This was in order to keep this part of the town strictly residential. This photograph of Bede Burn Road dates from 1906.

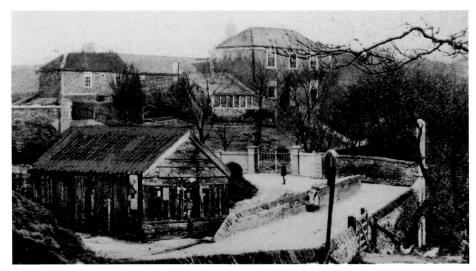

This image of Hedworth Hall was taken in 1896 after the 1930 passing of the owner and businessman market gardener Robert Jobling. His wife Dorothy eventually sold the property, but carried on the business from a smaller house, The Dene, to the left of the photograph. The old hall at this time was greatly in need of considerable attention and repair and was purchased by Mary Harris in 1932. The wooden barn at the bottom of the picture was part of Mill Farm. Although the road known as 'Fishers Dene' is still in use today, the buildings have long since been demolished.

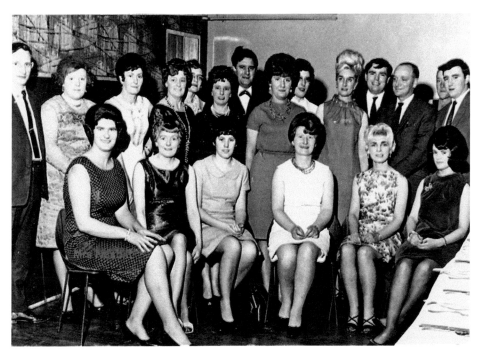

Staff from Morganite Resistors Ltd at the company's annual dinner and dance, 1964.

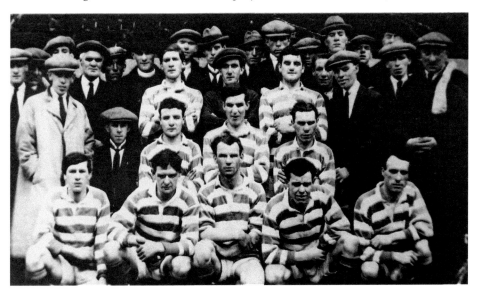

Since the middle of the nineteenth century north-east England has been associated with football, in both amateur and professional capacities. School teams from St Peter's, Ellison and the grammar schools were fine exponents of the game. But none compared with the boys clad in the green-and-white strip of St Bede's. Their success was due to the efforts of coaches Hugh Cunningham and Ned Burke, two devoted teachers at the Harold Street School. Their devotion and dedication to the team was rewarded with several successful seasons and winning the coveted St Oswald's Shield and League Cup eight years in succession. Pictured along with the team in this photograph from 1926 are teachers Felix Sullivan, Sep Mc Alarney and Pat Corr.

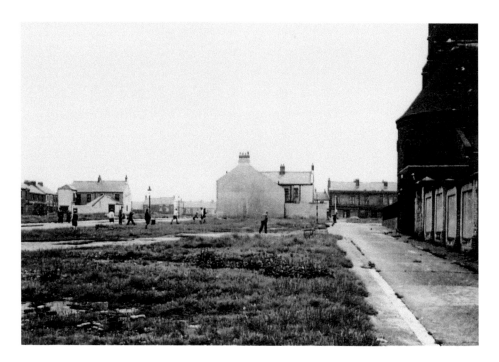

Above and below: Two differing images of Ferry Street from 1954. Around 1961, to accommodate the construction of the ten-storey Monastery Court, it became necessary to reposition the upper part of Ferry Street 200 yards in an easterly direction. This unusual step of 'doglegging' a street resulted in it being a continuation of Staple Road. Prior to this time, it was in line with Gray Street. Examination of an early map of the town will reveal precisely its former position.

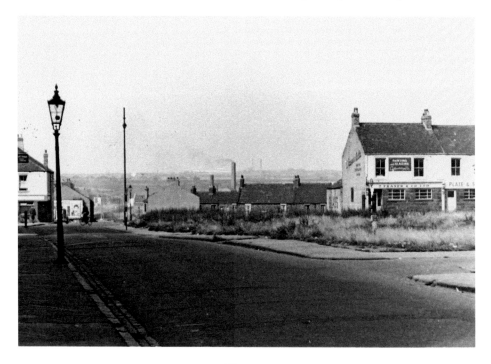

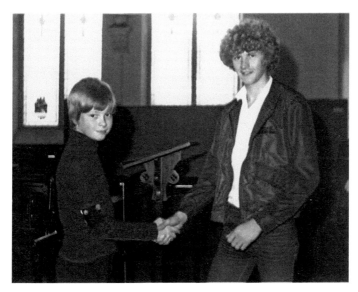

Above and below: Although he was born at Gateshead, Steve Cram's career was forged at Monkton Stadium, Jarrow, where he was motivated and mentored by none other than former sprinter-turned-coaching legend Jimmy Hedley. Steve carved out an unprecedented career spanning over three decades since appearing as a seventeen year old at the Commonwealth Games in 1978. The Jarrow Arrow's many achievements include six gold medals, attained at the Commonwealth Games and European World Championships. After an incredible season in 1983, he was voted BBC Personality of the Year, and three years later, in 1986, was awarded an MBE. At the 1984 Olympic Games at Los Angeles he returned from injury to take the silver medal in the 1,500 metres. The following year he succeeded to break three world records in the 1,500 metres, 2,000 metres and mile, all within a period of just nineteen days, holding the mile record for a total of almost nine years. Since retiring from competition, the adopted 'Jarra' lad has become a successful television commentator. Pictured here is Boys' Brigade member, ten-year-old Kevin Butcher being presented with an award. Wearing the No. 32 vest, nineteen-year-old Steve is seen in action on his home turf at Monkton Stadium, Jarrow. Both photographs were taken in 1978.

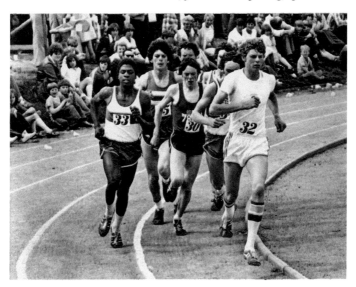

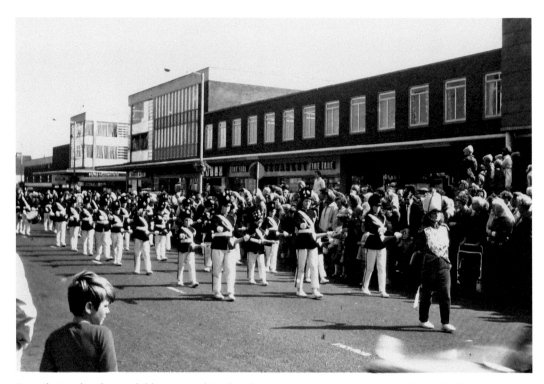

Juvenile jazz bands – a children's marching band – were exclusive to north-east England. The origin of the summertime activity is closely related to the days of the traditional miners' union and colliery brass bands, and form an important link to the British working-class families. Scores of bands from all parts of north-east towns and villages travelled the region for best band competitions during the summer months. Two of the most memorable in this region were the Calf Close Kilties and Hebburn Highlanders. This photograph was taken in Grange Road in 1972.

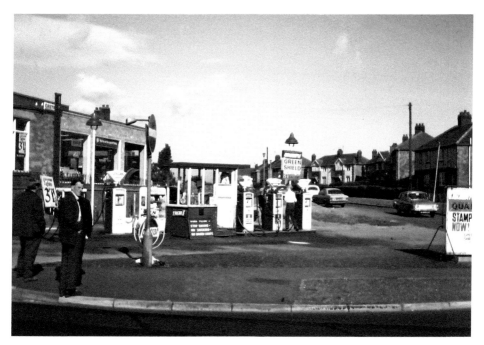

For several years York Avenue garage has been a reference point for anyone unfamiliar with the town. It was originally owned by the Jackson family, who constructed a car showroom when the company was chosen as a Volkswagen franchise during the 1960s. The successful dealership was subject to major refurbishment on three occasions since this photograph was taken in 1970, when petrol was 6s 2d (31p) per gallon, and a pint of best bitter was 3s (15p). These figures reveal a gallon of beer was, by far, much more expensive than a gallon of petrol.

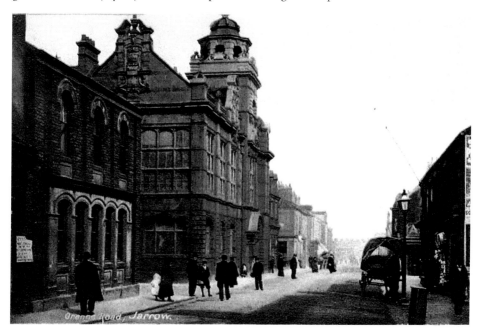

Grange Road in 1900.

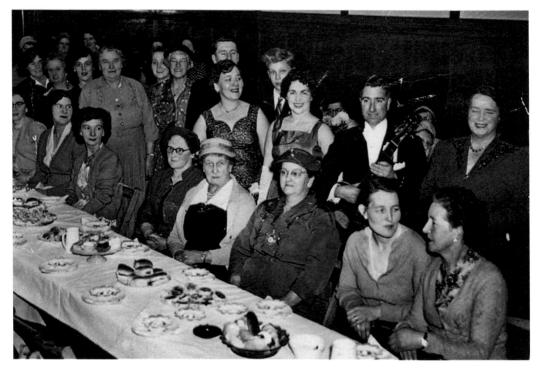

The traditional Lady Mayoress's annual charity event at the Civic Hall in the town, hosted by Mrs Rowan in 1960.

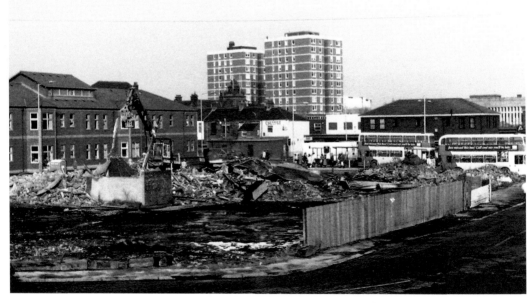

The creation of a more streamlined bus terminal came about as passengers were travelling further afield on the Metro after its inauguration in 1982. The site, which included the North Eastern Hotel and former Electricity Board showroom, was reclaimed for further development.

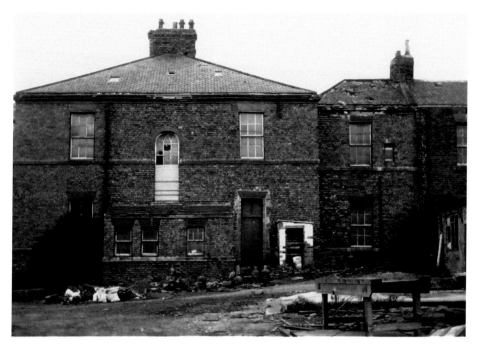

Above and below: After lying uninhabited and neglected for some considerable time, Simon Temple's former residence of Jarrow Hall, which dates from 1795, lay in a sorry and shameful state of dereliction. Jarrow Council, who were responsible for the decaying building, used it for storage up until 1970. From this time the building was rescued by St Paul's Development Trust (a charitable organisation), who sympathetically restored the building back to its original state, converting it into the Bede Monastery Museum. Today the museum, a thriving and popular venue, is known today as Jarrow Hall & Anglo-Saxon Farm.

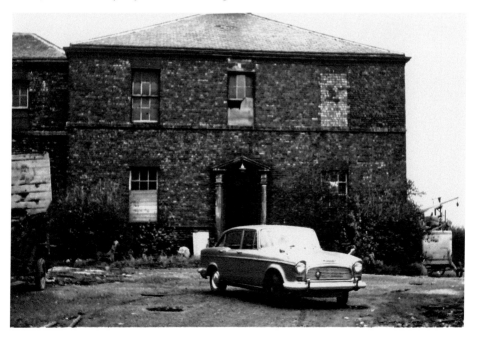

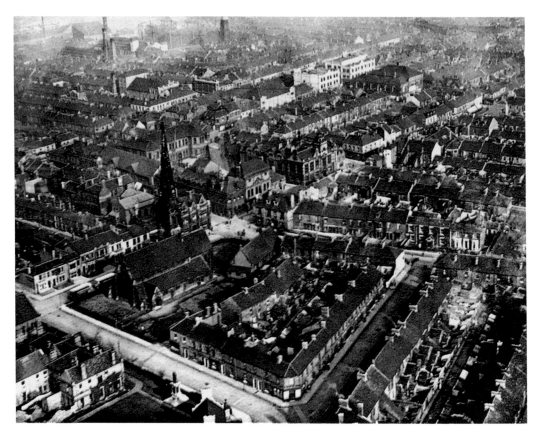

Further evidence of the town's industrial and lucrative past with the blackened buildings is portrayed here in this aerial image from 1925.

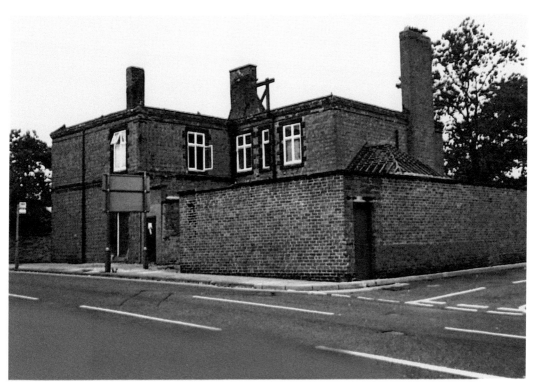

Above and below: Department of Social Security & National Insurance offices and staff in Park Road, 1953.

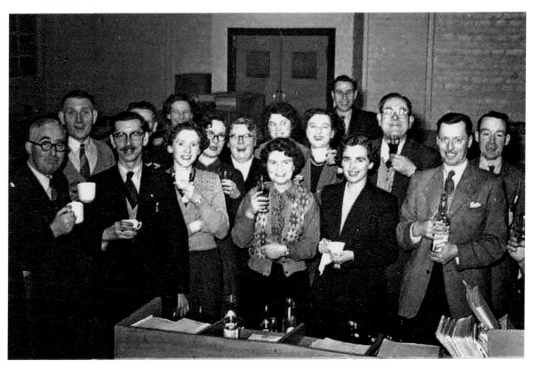

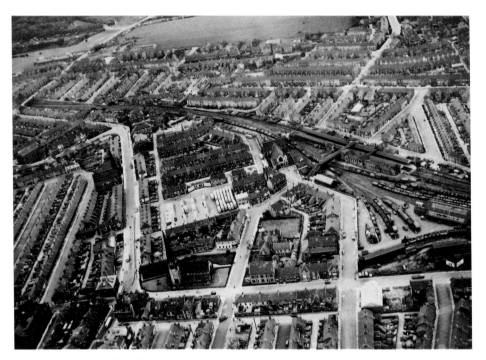

This aerial photograph of the central area was taken in 1954, shortly after the completion of the northern bus depot in the centre of the image.

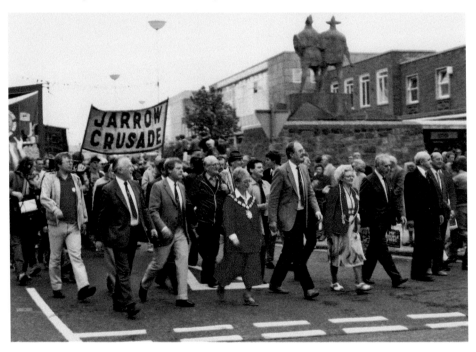

Mayor of Hackney, Councillor Dorice Shanks, together with the mayor of South Tyneside, Councillor Edith Battye, commemorate the 50th anniversary of the Jarrow Crusade, concluding with a demonstration in the capital against the 1986 unemployment situation.

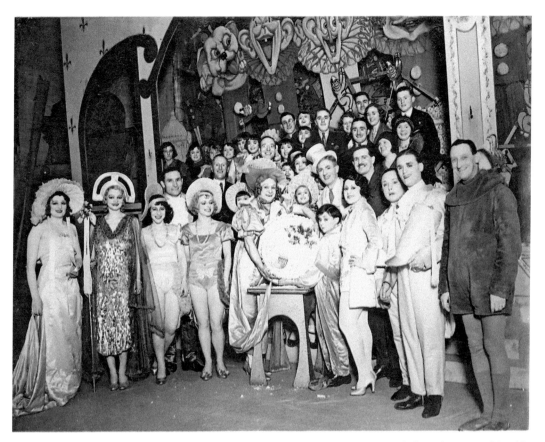

Born and bred in Jarrow in 1894, George Wood found fame as a music hall performer, making his debut performance at the age of five at the Theatre Royal in his home town. When fully grown, the 4-foot 9-inch dwarf performed the majority of his professional career in the guise of a schoolboy. His acting and writing career spanned in excess of half a century and was considered to have been one of the most prolific and successful pantomime stars of his era. Often starring alongside Laurel & Hardy, the comedian was inducted into the world of entertainment charity Grand Order of Water Rats, and elected King Rat in 1936. In 1946, he was awarded and decorated with the Order of the British Empire Medal for services to entertainment in the king's birthday honours list. The highly intelligent writer and entertainer converted to Catholicism early in his career and was so passionate about his religion he tried fervently to convert everyone he came into contact with. The pint-sized comedian was honoured to be selected to an audience with the pope. After an unusually lengthy discussion with the pontiff, Vatican security decided to intervene just in time to hear his holiness announce, 'But Mr Wood, I am a Catholic.' The veteran funny man and vaudeville star who lived for many years in the Bloomsbury region of London, married Ewing Eaton in 1933 and retired from the stage in 1953, but continued to write columns for the *Guardian* newspaper and entertainment magazine *The Stage*. He passed away in 1979, aged eighty-four years. Wee Georgie Wood is pictured here with Clarkson Rose and the cast of *Little Red Riding Hood* at Alexandra Palace Theatre, Birmingham, in 1933.

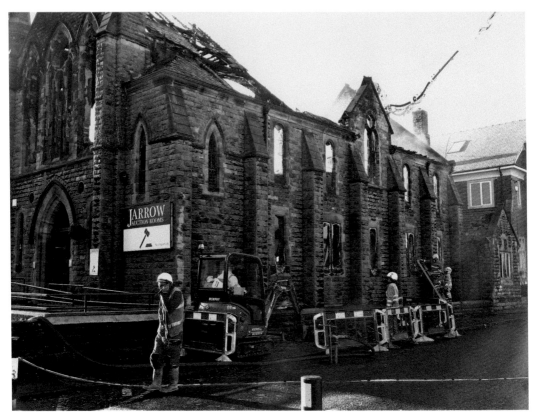

The remains of the former Park Methodist Church after fire ripped through the building. Close to fifty firefighters fought for three hours to bring the blazing building under control during the early hours of 24 November 2017.

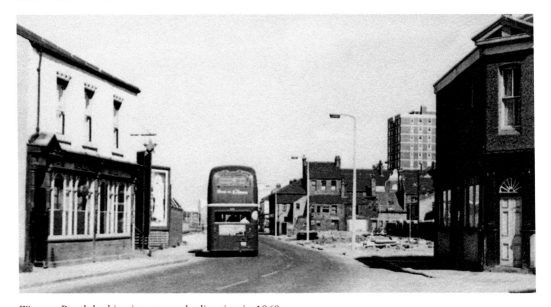

Western Road, looking in an easterly direction in 1969.

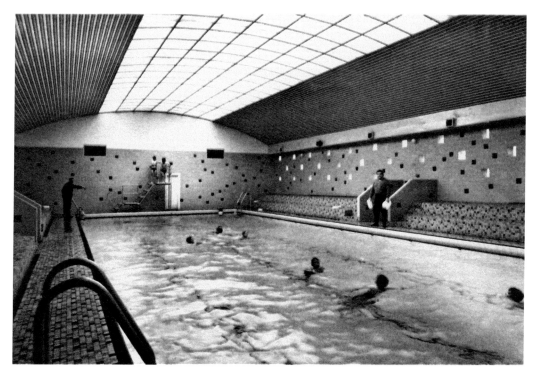

Opening in 1911, Jarrow public swimming baths in Walter Street served the town well until the opening of more modern facilities at Temple Park, South Shields. Pictured is the interior of the facility with the baths superintendent, the late Joe Metcalfe, on the right of this 1972 image.

St Agnes Women's Guild from 1950.

Valley View School football team from 1971.

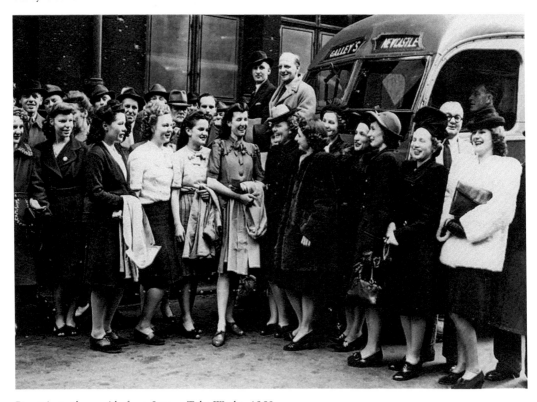

Day trip to the seaside from Jarrow Tube Works, 1958.

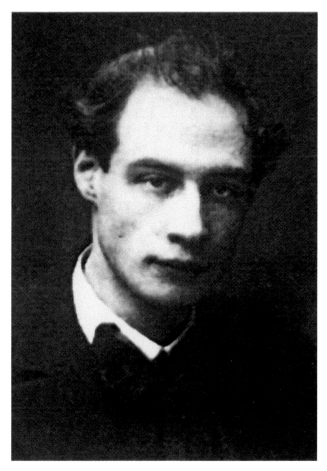

One of a family of fourteen children, John S. Clarke (pictured) was born in Albert Road in 1885 into a circus family. He spent his childhood busying himself doing odd jobs and tending to circus duties, paying special attention to grooming horses and at the same time acquiring a greater knowledge of circus procedure. In 1897, aged twelve, he joined the merchant navy and gained an extensive knowledge of the nautical world. Upon his return five years later, he returned home to circus life, and after befriending a lion tamer became his assistant. After a serious accident involving the circus's only big cat specialist, John, with his limited knowledge of taming the animals, stepped into the breech. He eventually became the country's youngest ever lion tamer. With his comprehensive knowledge of circus life, John wrote several articles on animal welfare and training for the *Newcastle Journal*. He also wrote a series of acclaimed books and published several works of poetry. In 1910, he relocated to Edinburgh and earned a living writing articles for newspapers and periodicals, eventually becoming editor in chief of the Labour Party newspaper, *The Socialist*. John, a known conscientious objector, joined the Independent Labour Party in 1927 and was elected councillor for a Glasgow ward, where he was successfully elected in 1929 as Member of Parliament for Maryhill. In 1931, he vehemently campaigned against income tax avoidance and the abolition of the death penalty. Returning to lion taming during the Second World War and continuing his career in journalism with the *Scottish Daily Express*. The intrepid Member of Parliament travelled the world on more than one occasion. For a time he was involved in gunrunning for Russian revolutionaries in 1905 and enthusiastically attempted to hitch-hiker home to Jarrow from South Africa. After an eventful and colourful life, John S. Clarke passed away at Glasgow in 1959.

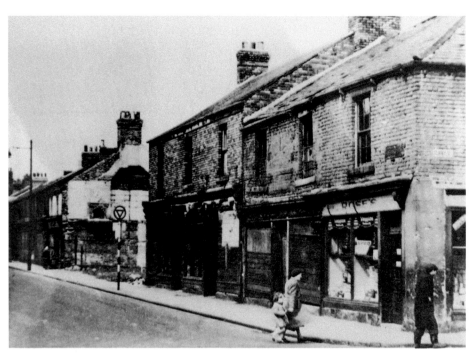

Junction of Ormonde Street and Ferry Street during post-war demolition in 1954.

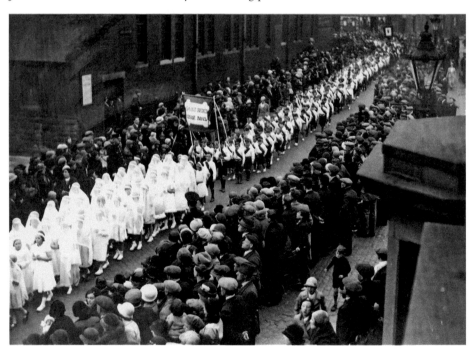

Procession to commemorate the 1,200th anniversary of the death of the Venerable Bede. The procession, which took two hours to complete through the streets of Jarrow, was witnessed by thousands of onlookers. The pilgrimage, photographed here in 1935 at the junction of Monkton Road and High Street, led by Cardinal Hinsley, terminated at the Drewett playing fields.

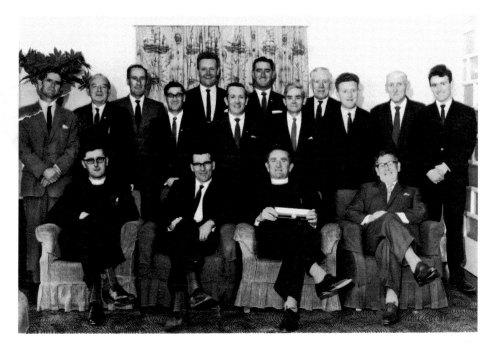

Father Rice, parish priest of St Joseph's Church, and committee members at the Deneside Catholic Club, 1970.

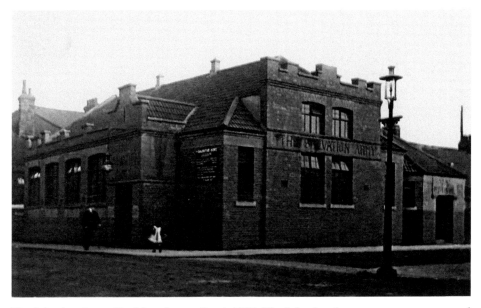

The Salvation Army Citadel at Grange Road, 1929. The Salvation Army movement was created by William Booth in 1865 and was established some thirteen years later in Jarrow in 1878. The inaugural meeting was conducted at the Civic Hall in Ellison Street. Later services were held in a purpose-built building in Grange Road until 1954, as the land it occupied and surrounding area was required for redevelopment. From this time the congregation worshipped at the old library building in Ormonde Street until 1963, when the present building in Monkton Road became available. In 2018, the organisation celebrated 140 years in Jarrow.

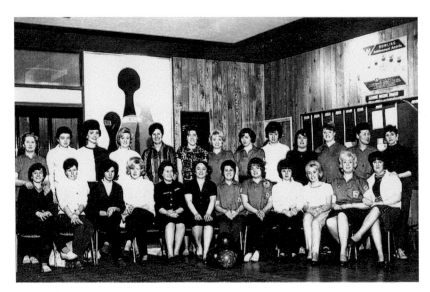

Above and below: Female bowlers from 1963, and the boys league team from 1965. American-style tenpin bowling centres were more popular in the south of the country during the 1950s, but the pastime eventually drifted north. Jarrow was chosen in 1962 as the location for the first of such centres, conveniently located on the ground floor of the recently constructed Arndale House. As the popularity of the pastime grew, leagues were formed as the craze swept Tyneside. Bowling centres were springing up seemingly overnight. In 1964, the Dogs Bowl was opened in South Shields on the site former of the Greyhound stadium. This was followed by Excel bowling centres at Sunderland, Gateshead and Newcastle. However, Jarrow's closed six years later in 1968. South Shields, Gateshead and Sunderland closed in the ensuing years as the game fell from popularity. Today the game has renewed popularity with recently opened bowling centres at Washington, South Shields and Metro Centre.

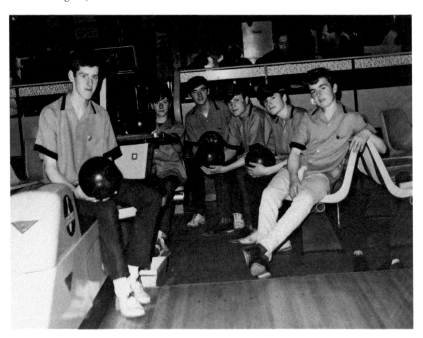

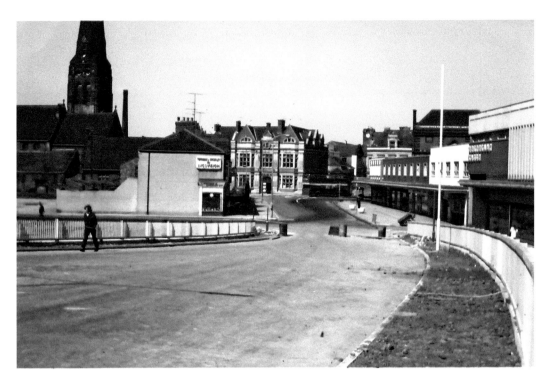

Ellison Street, 1967.

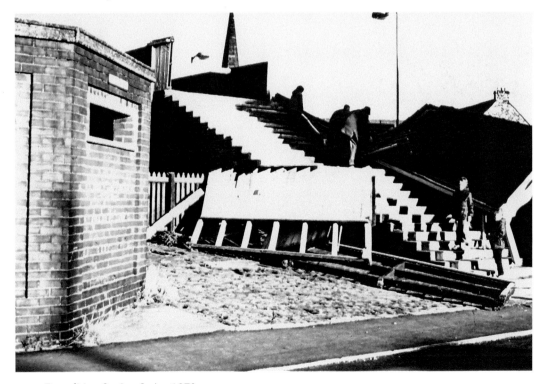

Demolition Station Stairs, 1973.

Acknowledgements

I would like to extend my gratitude to the following individuals and organisations for their assistance during the preparation of this book: Fred and Eileen Butcher, Anthony and Malcolm Perry, Sophie Brownson, Verity Ward, Angela and Oliver Snowden, David Drynan, Lawrence Cuthbert, John Joyce, Norman Dunn, Lorrain and Andrew Hillas, Revd Gerard Martin, Steve Cram MBE, David Morton, staff at South Tyneside, North Tyneside and Newcastle City Libraries, NCJ Media Newcastle, *Shields Gazette* and Amberley Publishing.